PRETENTIOUSNESS

PRETENTIOUSNESS

Why It Matters

DAN FOX

Coffee House Press
Minneapolis
2016

Coffee House Press books are available to the trade through our primary distributor, Consortium Book Sales & Distribution, cbsd.com or (800) 283-3572. For personal orders, catalogs, or other information, write to info@coffeehousepress.org.

Coffee House Press is a nonprofit literary publishing house. Support from private foundations, corporate giving programs, government programs, and generous individuals helps make the publication of our books possible. We gratefully acknowledge their support in detail in the back of this book.

LIBRARY OF CONGRESS CATALOGING-IN-PUBLICATION DATA

Names: Fox, Dan (Daniel Luke), 1976– author.
Title: Pretentiousness : why it matters / Dan Fox.
Description: Minneapolis : Coffee House Press, 2016.
Identifiers: LCCN 2015033491 | ISBN 9781566894289 (paperback) | ISBN 9781566894296 (eBook)
Subjects: LCSH: Performance. | Authenticity (Philosophy) | Creation (Literary, artistic, etc.) | BISAC: ART / Criticism & Theory. | LITERARY COLLECTIONS / Essays. | ART / Popular Culture. | PHILOSOPHY / Aesthetics.
Classification: LCC NX212 .F69 2016 | DDC 700—dc23
LC record available at http://lccn.loc.gov/2015033491

PRINTED IN THE UNITED STATES OF AMERICA

for Mum, Dad, Karl, Mark, Ellen, and Osian

Oh boy,
Sometimes it seems like it takes forever,
And then with your friends it takes no effort at all,
Oh it could be a past turn, attachment illusion,
That makes distance between me,
Leading a double, double life.

On the other hand you know it takes some language,
An agreement for the moment making dreams ring true,
So with the resistance comes an angel's assistance,
Brings it closer and closer
Leading a double life.

—"Blue" Gene Tyranny, "Leading a Double Life" (1977)

PRETENTIOUSNESS

MR. JOHNSON: So Harry says, "You don't like me anymore. Why not?" And he says, "Because you've got so terribly pretentious." And Harry says, "Pretentious, *moi*?" —*Fawlty Towers* (1979)

BILLY RAY VALENTINE: Motherfucker, *moi*?
—*Trading Places* (1983)

Start with the basics. (Presumably the least pretentious place to begin.) The Latin *prae*—"before"—and *tendere,* meaning "to stretch" or "extend," gives us the word "pretentious." Think of it as holding something in front of you, like actors wearing masks in the ancient Greek theater.

Or imagine yourself on a medieval battlefield, carrying a shield. In heraldry, the term "escutcheon of pretense" describes the coat of arms of a heraldic heiress, incorporated into her husband's own arms on the death of her father. In the absence of other male inheritors, the heiress's husband would "pretend" to represent the family. A shield was needed to protect your body in combat—held in front of you, *prae tendere,* like the actor's mask hides the face—but it also carried a design that boasted of your power and political authority. Your pretense was your protection, and could also make you into a target. (Since the fourteenth century, the Russian army has used a strategy of deception they call

maskirovka—"something masked"—to hide, deny, or divert attention away from real military maneuvers.)

In politics the claimant to a throne or similar rank was known as a "pretender." Upheavals in England, Scotland, and Ireland brought about by the "Glorious Revolution" in 1688, for example, saw the overthrow of the last Stuart king, the Catholic James II, by the Protestants William and Mary. Subsequently, two "pretenders," James II's son and grandson, made claims to the English crown. (The most famous of these was the "Young Pretender," Charles Edward Stuart, also nicknamed Bonnie Prince Charlie.) To be called a "pretender" was not necessarily an insult; the issue was the legitimacy of the claim you held before you, *prae tendere.* Authority was recognized on the basis of your political allegiance and religious belief, not questions of truth or falsity. This pretense was not an act. It was a matter of blood and God.

Go back to the actor and the mask. In classical Greek theater the word *hypokrités*—from which we get "hypocrisy"—was the standard term for actors, deriving from the words *hypó* ("under") and *krisis* ("decide," "distinguish," or "judge"). It was a way of describing a dissembler, the faces of the mask and the actor beneath it. When St. Paul, in his epistle to the Romans, wrote "Let love be not hypocritical," he used the word in this Greek sense, meaning "actor." Paul meant that love should not hide itself behind a mask representing love, or use words signaling it insincerely.

"Man is least himself when he talks in his own person," wrote Oscar Wilde. "Give him a mask and he will tell you the truth." Well, maybe. It depends on the time and place. Theater, cinema, and broadcasting provide the professional

license to wear one. We derive pleasure from the deceits of the stage illusionist, whose acts of fakery we pay money to watch. (Magician James "The Amazing" Randi describes himself as "an honest liar.") In carnival and ritual too, the mask is socially sanctioned. Outside these fields the actor's mask is suspect. So we smear it with the brush of immaturity, dismissing it as "pretending."

Pretending is what kids do to figure out the world. Children do not put on airs. A child might be precocious—from the Latin *prae*, "before," and *coquere*, meaning "to cook," that is, precooked or ripened early—but it's rare that a child is called pretentious. That insult is reserved for the pushy parents; pretending is what's done at the kid's table, pretension goes on over the wine and cheese course with the grown-ups. Pretending reminds adults of childish things long put away, of imaginary friends, and of the companionship found in favorite teddy bears and dolls, in toys we imagined to have distinct personalities and the stories we swaddled them in. To pretend is to live in denial of "real" grown-up problems. It's child's play.

And a play is also what professional actors are employed to make onstage in theaters. "Acting is a reflex, a mechanism for development and survival," writes theater director Declan Donnellan in *The Actor and the Target*. "It is not 'second nature,' it is 'first nature' and so cannot be taught like chemistry or scuba diving." Acting is a tool of every social interaction we have from birth. "Peek-a-boo," says Donnellan, is the first play a baby enjoys,

> when its mother acts out appearing and disappearing behind a pillow. "Now you see me; now you don't!"

The baby gurgles away, learning that this most painful event, separation from the mother, might be prepared for and dealt with comically, theatrically. The baby learns to laugh at an appalling separation, because it isn't real. Mummy reappears and laughs—this time, at least. After a while the child will learn to be the performer, with the parent as audience, playing peek-a-boo behind the sofa. . . . Eating, walking, talking, all are developed by observation, performance, and applause. We develop our sense of self by practicing roles we see our parents play and expand our identities further by copying characters we see played by elder brothers, sisters, friends, rivals, teachers, enemies or heroes.

"Born Originals, how comes it to pass that we die Copies?" asked Edward Young in his *Conjectures on Original Composition.* Young would argue that mimicry blots out individuality. But mimicry is a mechanism by which we become socialized, by which we make ourselves human. It doesn't take a sociology PhD to recognize that we pretend every day: pretend to be absorbed in a book to avoid catching the eye of a stranger on the bus, pretend to be pleased to see your boss when you arrive at the office. Putting on a suit allows you to pretend you're efficient or powerful when you would rather be in your pajamas in front of the TV. You might wear jeans and a T-shirt to the office to pretend to your coworkers you are laid-back when your personality tends toward the uptight. It's hard to admit to pretending because in Western society no one likes a faker. Great store is placed

on "keeping it real." We tell those with unrealistic expectations to "get real," "face reality," or "wake up and smell the coffee," as if the rest of their activities were a dream.

Yet we value dreams. "We are such stuff as dreams are made on," wrote Shakespeare. Four hundred years later his line from *The Tempest* would be printed on motivational posters, accompanying a soaring eagle or spectacular sunrise. "Keep hold of your dreams," we advise. "What's your dream job?" "Who is the man/woman of your dreams?" The contradictory impulses to both dream and face the truth find uneasy reconciliation in the language of the workplace. "Act like you mean it." We refer to "acting on behalf of" a person or organization, or "playing a part" in a project. Your boss assesses you on your "performance" in the job, a "role" that might be rewarded with "performance-related pay." "Dress for success," say the career gurus. "Dress for the job you want, not the one you have." "Look smart." The cover headline of the January–February 2015 edition of the *Harvard Business Review* reads: "The Problem with Authenticity: When It's O.K. to Fake It till You Make It." The article explains "why companies are pushing authenticity training" and advises its readership that "by trying out different leadership styles and behaviors, we grow more than we would through introspection alone. Experimenting with our identities allows us to find the right approach for ourselves and our organization."

Play, according to psychologist D. W. Winnicott, allows children to see, risk-free, what happens when their internal world engages with the external one. Yet by the time you reach an age at which you can legally drink, vote, drive, consent to sex, or get married, it's presumed you know where to

draw the line between fact and fantasy, where innocent play congeals into pretension. And nobody wants to be accused of that. In his 1996 diary, published as *A Year with Swollen Appendices,* musician Brian Eno describes how he

> decided to turn the word "pretentious" into a compliment. The common assumption is that there are "real" people and there are others who are pretending to be something they're not. There is also an assumption that there's something morally wrong with pretending. My assumptions about culture as a place where you can take psychological risks without incurring physical penalties make me think that pretending is the most important thing we do. It's the way we make our thought experiments, find out what it would be like to be otherwise.

If "pretending is the most important thing we do," then what bred such discomfort with it?

DES MCGRATH: You know that Shakespearean admonition, "To thine own self be true?" It's premised on the idea that "thine own self" is something pretty good, being true to which is commendable. But what if "thine own self" is not so good? What if it's pretty bad? Would it be better, in that case, not to be true to "thine own self"? —*The Last Days of Disco* (1998)

Plato hated actors. (So too did my Irish grandmother, who reserved the term "actor" for one of her sharpest put-downs.) The mimesis of theater, thought Plato, could only lead to self-corruption; if you played a slave you might end up servile off-stage too. He argued that imitation was mere rhetoric, incapable of expressing the truth like philosophy could. Indeed, European acting history became bound up with the rules of classical rhetoric used by lawyers, theologians, and diplomats. Stage acting came straight from the legal and political toolboxes of persuasion. The history of pretense is tied up with the history of power.

Around 350 BC, Aristotle produced *Rhetoric,* his treatise on the principles of oratory. He extrapolated from Greek theater the different techniques used on stage by the *hypokritai* of his day—individuals who could command the attention and emotions of large audiences—and applied them to the courtroom. Aristotle defined ten categories of emotion, which might be activated according to circumstance: Anger,

Calm, Friendship and Enmity, Fear and Confidence, Shame, Favor, Pity, Indignation, Envy, Jealousy. "Aristotle's principles of rhetorical delivery are explicitly derived from the best actor's practice," argues theater historian Jean Benedetti. "Control and command of pitch, dynamics, stress, rhythm, range, flexibility, together with appropriate body language, were essential." The legal advocate needed to play on emotions in order to build a persuasive argument, to pull judges onside. "Thus by a significant reversal, actors' practice was enshrined in the principles of rhetoric, which then, historically, became a prescriptive set of rules for the actor."

The Roman philosopher-politician Cicero and the rhetorician Quintilian built on Aristotle's work. In *On the Orator,* written in 55 BC, Cicero examined the relationship between bodily gestures and tone of voice, purity of diction, memorizing an argument, and the most suitable words for a situation. Quintilian's twelve-volume *Institutes of Oratory,* produced in the first century AD, was designed as an educational manual, leading would-be orators through the various principles of the art and the stages of training in minute detail. Having existed only in fragments for many centuries, the complete manuscript for *Institutes of Oratory* was rediscovered in the basement of a Swiss monastery during the fifteenth century, consolidating its status as one of the most influential texts on the subject. In the fourth century AD, following his conversion to Christianity, St. Augustine of Hippo applied the principles of pagan Greek and Roman rhetoric to preaching. Augustine argued that the art of rhetoric was neutral, that it could be applied for both good and bad purposes—worn like a costume or mask, you might say—and that its

powers of persuasion could be used for spreading the teachings of Christianity.

In England, stage acting had been shaped during the Elizabethan and Jacobean eras by a fusion of techniques learned from classical rhetoric and by the vernacular styles of medieval mystery and morality plays. Acting in Shakespeare's day was expansive and colorful, big enough to hold the attention of large outdoor audiences, but not without elements of naturalism. When Shakespeare's star actor Richard Burbage died, an anonymous fan wrote: "Oft I have seen him leap into the grave / Suiting the person which he seemed to have / Of a sad lover with so true an eye / That there I would have sworn he meant to die." Theater was banned altogether under Oliver Cromwell's Commonwealth until the Stuart Restoration in 1660. Then the favored acting style was mostly neoclassical, a highly mannered declamatory form governed by rigid codes derived from manuals of rhetoric. In French theater of the same period, artifice and adherence to prescriptive rules of performance were placed front and center. Deviation from those rules was strictly policed.

There was a shift during the eighteenth century, when the English actor David Garrick and his Irish contemporary Charles Macklin began to develop more naturalistic approaches to acting. Personal experience and observation of life began to influence performance, rather than bombast and affected speech. A driving force behind the move toward a more naturalistic style was Aaron Hill, editor and publisher of *The Prompter.* "The actor who assumes a character wherein he does not seem in earnest to be the person by whose name he calls himself, affronts instead of entertaining

the audience," wrote Hill in the June 13, 1735, edition of his magazine. "Have we not a right to the representation we have paid for?"

Despite the influence of romanticism on the theater, French acting techniques remained mired in the courtly neoclassical style until the end of the nineteenth century, when writers and theater producers—frustrated at the limited skills of their performers—demanded a naturalism that would more accurately reflect society's problems at the turn of the century. The acting teacher François Delsarte developed a popular system that claimed to connect every conceivable emotion with a physical gesture. It was a standardized approach to body language, developed from years Delsarte spent observing human behavior in a variety of situations. His hope was to give actors more precision in their capacity to express human experience. Through his protégé, the American Steele MacKaye, and the publication in 1885 of *The Delsarte System of Expression*—a handbook compiled by MacKaye's student Genevieve Stebbins—the French teacher's ideas spread rapidly throughout the US. But there Delsarte's system petrified into melodramatic, stiff forms of acting.

The Russian stage, by contrast, was revolutionized by the work of Pushkin, Gogol, and the actor and director of Moscow's Maly Theatre, Mikhail Shchepkin. Their techniques of "psychological realism" required a deep level of belief on the part of the actor that he was truly living the situation and character he was playing. Actors began to dispense with using recognizable sets of gestures and instead concentrated on the internal drive of a given character. Shchepkin's ideas were eventually passed down to Konstantin Stanislavski,

who developed the "System." Stanislavski's theory was that an actor could produce emotional responses by fusing observations of human behavior with personal lived experience, and feed that into the onstage character. "Always and forever, when you are on the stage, you must play yourself," says the director in Stanislavski's book *An Actor Prepares.* "But it will be an infinite variety of combinations of objectives and given circumstances which you have prepared for your part, and which have been smelted in the furnace of your emotion memory."

The Russian's ideas traveled to the US in the 1920s. Lee Strasberg's "Method" technique, developed at the Actor's Studio in New York, was an interpretation of Stanislavski that placed strong emphasis on "emotion memory." (Strasberg's colleagues Stella Adler, Elia Kazan, and Robert Lewis disputed this approach.) The Method encouraged actors to physically live through the experiences of the characters they were to play. If the actor knew what it was like to inhabit a certain kind of body, to feel similar things to their character, then their performance would be all the more "authentic." Think of Robert De Niro putting on sixty pounds in weight in order to play the washed-up boxer Jake LaMotta for Martin Scorsese's film *Raging Bull,* or Daniel Day-Lewis learning to hunt and survive off the land for his role as the tracker Hawkeye in Michael Mann's *The Last of the Mohicans.* The Method proved to have its own restrictions. "In basing his gestures on his observations or on his own spontaneity," wrote director Peter Brook, "the actor is not drawing on any deep creativity. He is reaching inside himself for an alphabet that is also fossilized, for the language of

signs from life that he knows is the language not of invention but of his conditioning." David Mamet puts it more bluntly: "Nothing in the world is less interesting than an actor on the stage involved in his or her own emotions. The very act of striving to create an emotional state in oneself takes one out of the play."

Bertolt Brecht came into contact with Stanislavski's theories through Russian exiles in 1920s Berlin. Brecht, a committed Marxist, held that naturalistic and realist styles of acting did nothing but reproduce on stage the status quo in society, giving the audience an emotionally cathartic experience that left them feeling superficially "purged" but unwilling to demand real change once they left the theater. Brecht believed that it was the actor's job to make the audience understand that social reform was possible, and developed the concept of "Epic Theater" in which the audience would be made critically aware that the action they were watching on stage was an artificial representation of real life. The emphasis was on highlighting the pretense, not hiding it. Brecht had also come under the influence of Chinese theater in the 1930s, after watching Mei Lanfang perform in Moscow, an actor who appeared to be both "in character" and at the same time remote from his role.

Oratory, naturalism, artificiality. Aristotle, Garrick, Stanislavski, Brecht—whichever way you slice it, doesn't acting always just come down to a paid form of pretense? What does this back-of-an-envelope history of acting tell us about our fears of pretension? One thing it shows is how gestures cribbed from classical rhetoric slowly morphed into techniques of acting that placed an emphasis on the "inner truth"

of a character. It demonstrates the evolution of complex rela-
tionships to both artifice and naturalism. And that's the
key. What this thumbnail history of professional pretending
loosely tracks is the evolution of "authenticity," a contradic-
tory value in Western society that's come to dominate con-
temporary ideas of identity.

The motto of the Globe Theatre in London was *Totus
mundus agit histrionem*; "The whole world is a playhouse."
Shakespeare adapted the phrase to "All the world's a stage."
In a series of lectures on the subject of "Sincerity and
Authenticity," the literary critic Lionel Trilling held the view
that in Shakespeare's era, people acted a part in a rigid social
system, a little like actors adhering to a set of external ges-
tures learned from manuals of rhetoric. If you were true to
the persona you presented to others, then you could commit
no falsehood. Being sincere to "thine own self," as the line
from *Hamlet* goes, was the most important moral aspiration,
and that morality was derived from external sources: your
place in the social hierarchy and, ultimately, God.

Cracks began to appear in this casting system during
the Enlightenment. Trilling shows how Denis Diderot sati-
rized the social hierarchy in his dialogue *Rameau's Nephew:*
"Everyone in society, without exception, acts a part, takes a
'position,' does his dance, even the King himself, 'who takes
a position before his mistress and God: he dances his pan-
tomime steps.'" (Diderot had a keen interest in acting: he
held that actors should be cool-headed and in control, not
give themselves up to emotion. He had seen Garrick per-
form and admired his work, although Garrick never dis-
counted the possibility that tapping into personal passions

might be useful in performance.) Thinkers such as Johann Gottfried von Herder and Jean-Jacques Rousseau began to doubt the validity of socially constructed roles, instead looking inward for an answer, to base their morality on a voice of nature within themselves. Discovering and being true to your own nature became the primary moral aspiration; it was what you brought to your character and its role in society. God did not entirely recede from the conversation but had to make room for human individuality.

In the modernizing world, the potential of this "authentic" individual was key to the march of democratic equality. "It is a great and beautiful spectacle to see man raising himself from nothingness by his own efforts; dissipating with the light of his reason, the shadows in which nature enveloped him" wrote Rousseau. "And, what is still greater and more difficult, returning into himself, to study man and get to know his nature, his duties, and his end." Human nature terrified thinkers such as Edmund Burke, who preferred the old world's way of doing things. In his book *The Politics of Authenticity*, philosopher Marshall Berman finds Burke lamenting the French Revolution—when authenticity, purity, and self-sacrifice in the name of political ideals became all-important values in the lead up to the Terror:

> All the pleasing illusions which made power gentle and obedience liberal, which harmonized the different shades of life, and which, by a bland assimilation, incorporated into politics all the sentiments that beautify and soften private society, are to be dissolved by the new conquering empire of light and reason.

As if to emphasize the importance of performance—of truth to surface ideals—Burke used the metaphor of costume or décor to describe his horror at the social upheaval: "All the decent drapery of life is to be rudely torn off."

Discovering the truth of one's inner self—no matter how flawed that might be—became an imperative in romantic and modernist art and philosophy, just as Shchepkin, Stanislavski, and, later, Strasberg taught actors to find the truth of their roles in personal experience. Artists were to seek creative autonomy. Their "moral accreditation," as Trilling called it, would be earned by facing up to pain and suffering or by having the courage to reflect society's ills in pursuit of their art. For John Stuart Mill, the liberty of the individual was a bulwark against the tyranny of both state rule and the unchecked power of the crowd. Karl Marx argued that the proletariat needed to discover a sense of its authentic self in order to provide the foundations for revolution. What grew from all this was the idea of "being yourself." In his film *The Century of the Self,* Adam Curtis traces the evolution of this individualism during the twentieth century, and its startling intersections with Freudian psychoanalysis, advertising, and the counterculture. Curtis describes "being yourself" as "an idea that has come to dominate our society . . . the belief that the satisfaction of individual feelings and desires is our highest priority."

Capitalism, the dominant political ideology of the West in the twentieth century, would valorize the individual in order to extract value from it. (The greater the number of individual needs there are to cater for—the more desires that need satisfying—the more opportunities exist to make

money off them.) Championing the individual was a way to fend off communist bogeymen. But both the political right and left had faith in the individual. The left came to believe that capitalism alienates and exploits us; the right, that state government keeps true liberty out of our reach. In both worldviews a personal authenticity is prevented from flourishing. For Berman, this idea of self-realization was contradictory:

> After all, isn't everyone himself already? How can he help being himself? Who or what else could he be? To pursue authenticity as an ideal, as something that must be achieved, is to be self-consciously paradoxical. But those who seek authenticity insist that this paradox is built into the structure of the world they live in. This world, they say, represses, alienates, divides, denies, destroys, the self. To be oneself in a world is not a tautology but a *problem.*

Philosopher Charles Taylor sees authenticity as a process of creation as well as self-discovery, "a self-definition in dialogue"—we establish our authenticity in conversation with those around us. In the eyes of democratic society, pretending to be something other than your true nature is to break a social contract. It's not part of the democratic process. And why would you ever squander the right to "be yourself"? So many millions of lives have been lost defending the right to be oneself from tyranny and ideology (or waging war using that reason as a mask) that to explain why seems self-evident, absurd. Denounce pretension and you are

on the right side of history, upholding the hard-won ideals of democracy—where you keep it real, where you're true to your school.

Aristotle took acting techniques from the stage and brought them into the legal, academic, and political fields for his treatise on rhetoric. These skills drifted back into the theater, but left indelible stains on the function of law, government, and the professions. Lawyers put on an act in order to convince a judge and jury. Politicians will dissemble by any means necessary to make voters believe their promises are genuine. Medical professionals "act" in front of patients to make them feel comfortable or take their advice seriously. A discomfort with pretense is also a discomfort with power, or with the fear that nobody is in control, only acting as if they are.

In Bruce Robinson's comedy *Withnail and I*, a portrait of two unemployed actors at the dismal end of the 1960s, drug dealer Danny describes the occasion when a friend of his, known as "the Coalman," turns up to court dressed in a kaftan, on a narcotics charge.

> So, there's this judge sitting there in a cape like fucking Batman with this really rather far-out looking hat. He looks at the Coalman and says "What's all this? This is a court, man. This ain't fancy dress." And the Coalman looks at him and says "You think *you* look normal, your honor?" Cunt gave him two years.

Politics, religion, and law work their magic on us through images and symbols, costume, and ceremony. Jerry Brown,

governor of California, once observed how "a lot of [politics] is theater. How do you communicate to 38 million people? You're not sitting down talking to them. So it's gesture, symbol, the narrative, the drama. Who's the protagonist? Who's the antagonist?"

In the US, where the myth of opportunity and of a level playing field for everyone remains powerful, presidential hopefuls need to convince the electorate and party donors that they're a safe pair of hands. A candidate must be able to stand alongside powerful actors on the world stage and appear at ease with captains of finance. They also need to be seen in rolled-up shirtsleeves with the ordinary folk, perhaps accentuating the more regional tics in their accents and playing up a humble family backstory, subtly evoking the Horatio Alger archetype of the ordinary citizen rising to an extraordinary position of influence. Barack Obama modulates his accent according to his audiences, code-switching from African American vernacular English to folksy southern drawl, knowing when to affect the cadences of the preacher and when to use the measured tones of the academic. In the UK, where questions of class are fiercely foregrounded, where there exists a complex love-hate relationship to the patrician classes, politicians might be just as successful emphasizing privilege as ordinariness. A figure such as the conservative politician Boris Johnson acts the posh but rumpled country gent, his bumbling but charming public persona seemingly taken from the pages of a P. G. Wodehouse novel, even though we recognize that underneath Johnson's boyish thatch of blond hair exists a politician as steely as any other. It's *Jeeves and Wooster* retooled as PR.

Politics is a game in which actors assert their authenticity in the face of other actors whom they accuse of bad faith. Think of the embattled conservative candidate who, faced with hard questions about policy or public gaffes, plays the "biased liberal media" card. Appeals are made to a silent majority sitting in the stalls, drowned out by the hecklers positioned up in the gods: socialists, liberals, gays, feminists, women, Muslims, Jews, immigrants, the BBC, "the political correctness brigade." A phantom "cultural elite" is conjured onstage, working against what "real," "ordinary" people wish. (As if "real," "ordinary" people could not possibly be left-wing, or gay, or interested in equality, or hold different religious beliefs.) It's nothing more than smoke and mirrors, a game of pretense, but the idea of the "ordinary" person is a powerful rhetorical image.

In his essay "Politics and the English Language," George Orwell castigates political writers on both the left and right for their use of "dying metaphors," "verbal false limbs," "meaningless words," and "pretentious diction." Orwell observes: "Words like *phenomenon, element, individual* (as noun), *objective, categorical, effective, virtual, basic, primary, promote, constitute, exhibit, exploit, utilize, eliminate, liquidate,* are used to dress up simple statements and give an air of scientific impartiality." He sees how "adjectives like *epoch-making, epic, historic, unforgettable, triumphant, age-old, inevitable, inexorable, veritable,* are used to dignify the sordid processes of international politics." Orwell's arguments, written in 1946, appear obvious to media-literate voters today, but the emotional grandstanding of partisan politics in the twenty-first century only seems to reinforce his points.

Words are put to more duplicitous use in affairs of state than ever before.

"In modern political performances," writes Richard Sennett in *The Culture of the New Capitalism,* "the marketing of personality further and frequently eschews a narrative of the politician's history and record in office; it's too boring. He or she embodies intentions, desires, values, beliefs, tastes—an emphasis which has again the effect of divorcing power from responsibility." The consummate politician is a screen onto which are projected the nebulous desires of the electorate, media and business. Here we might think of Jerzy Kosiński's 1970 novella *Being There*—later turned into a film starring Peter Sellers—which tells the story of Chance, a sheltered, innocent gardener who finds himself accidentally dropped into a frenzied media circus in which his simple pronouncements on gardening are taken for profound nuggets of political wisdom. Chance symbolizes whatever anyone wishes him to symbolize.

In Robert Altman and Garry Trudeau's mock documentary series *Tanner '88,* a fictional presidential candidate, Jack Tanner, shoots for election under the slogan "For Real." The series—filmed on the 1988 presidential campaign trail—features cameos from political figures including Bob Dole, Kitty Dukakis, Pat Robertson, and Jesse Jackson. Accentuated by the fly-on-the-wall style of the film, the juxtaposition of actors performing as politicians alongside real politicians performing in ways they hope will earn them real votes throws into relief the degree to which acting plays a part in public life. Who, we find ourselves asking, is really doing the pretending here?

George Clooney and Steven Soderbergh's 2003 TV series *K Street* blurred the lines even further. *K Street* starred real-life Washington husband-and-wife political consultants James Carville and Mary Matalin playing themselves alongside actors within a fictional bipartisan lobbying company. In one scene, the tough-talking Carville and his business partner Paul Begala are seen coaching Democratic presidential hopeful Howard Dean ahead of a debate in Baltimore. Carville arms Dean with a line to use if faced with a difficult question about the racial demographics of his state, Vermont, which Dean goes on to use in the real debate. In that same episode, we see Carville—sat next to the actor John Slattery—laughing at the television broadcast of Dean repeating his line. As Ronald Brownstein asked in the *Los Angeles Times*,

> What did the camera capture at that moment? Was that the fictionalized Carville laughing in pride, to advance a plot point scripted by the producers? Or was that the real-life James Carville laughing at the absurdity of a candidate in the actual presidential election using a line he heard while participating in the filming of a half-hour drama series on HBO?

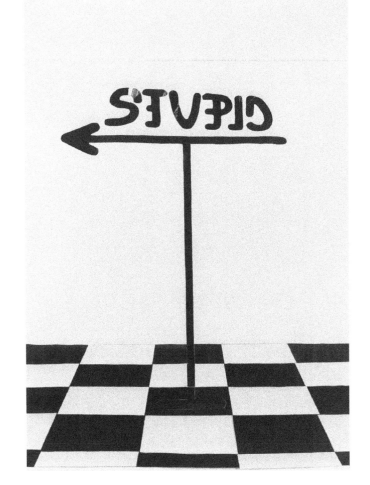

To go further in our search for some antidote against Melancholy, we may seek in our dust-heap for some rigid, and even splendid, attitude of Death, some exaggeration of the attitudes common to Life. This attitude, rigidity, protest, or explanation, has been called eccentricity by those whose bones are too pliant. But these mummies cast shadows that do not lie in their proper geometrical proportions, and from these distortions dusty laughter may arise.

—Edith Sitwell, *English Eccentrics* (1933)

RENEE: Do you think he's the murderer?
ROBERT: It's worse than that—he's an actor.

—*Gosford Park* (2001)

Experts authenticate. They can tell you whether or not the painting signed "van Gogh" you found in your great aunt's attic is worth taking to the auction house or the flea market. They can tell you if the cash in your pocket is real or counterfeit, or if the fingerprints on the stolen gold bullion are those of the prime suspect. Authentication tells you whether something is worth it or not: worth the price you paid, the cost of admission, your admiration and respect. It is a matter of authority, of who gets to pass judgment on whether or not you are "being yourself," of whether the pretender to the throne holds a legitimate claim or not. When we

believe a person's authority on a subject we call them a connoisseur or specialist. If that knowledge makes us uncomfortable, we damn them as geeks or "self-appointed" experts, we accuse them of lording their obscure tastes over our common, shared references.

Actors can manipulate the emotions of an audience. It's why some of us distrust them. But there's also an argument that acting shows off the human ability to empathize. Crucially, acting suggests that we can change and become someone else. That life, if you're lucky, offers alternatives. As we mature we become different people, wear different clothes, change opinions, make new lifestyle choices. Every New Year we make resolutions that we kid ourselves will change who we are for the better.

When authenticity is in question, it generates deep anxieties. These worries are ancient. Stories about people not being who they say they are, or who we think they are, can be traced back to tales of shapeshifting gods playing among mortals, or changelings taking the place of human children. They can be found in Homer's *Odyssey*, Ovid's *Metamorphoses*, and Valmiki's *Ramayana*. Think too of Shakespeare's comedies of mistaken identity—*As You Like It*, *A Comedy of Errors*, *Twelfth Night*—or the pranks played by the woodland gods on the lovers and amateur actors in *A Midsummer Night's Dream*. The trope can be found in novels such as Robert Louis Stevenson's *Strange Case of Dr. Jekyll & Mr. Hyde* and Anthony Hope's *The Prisoner of Zenda* or Oscar Wilde's play *The Importance of Being Earnest*. It's the narrative driving ballets such as *Coppélia, Swan Lake,* and *Giselle*. Cinema is full of such stories: *Seconds, Easy*

Living, North by Northwest, Vertigo, Trading Places, The Big Lebowski, Mr. Klein, The Guv'nor, The Talented Mr. Ripley, Big Business, The Return of Martin Guerre, The Parent Trap, Dead Ringers, Freaky Friday, Top Hat, The Court Jester, El Mariachi. We enjoy films in which actors play versions of themselves which may or may not be accurate—John Malkovich in *Being John Malkovich,* Elliot Gould and Julie Christie performing their own celebrity in *Nashville,* Joaquin Phoenix in *I'm Still Here.* The enduring popularity of these story archetypes says something about a collective fascination with role-playing, fears about identity, age-old debates about nature versus nurture, and the superstition that life's trials are simply the gods screwing with us. They tap into the existential suspicion that identities might be mutable— like the time-traveling, gender-swapping protagonist of Virginia Woolf's novel *Orlando: A Biography.* Dissemblance is enjoyable when it's kept safe inside the local multiplex or the pages of a novel, but once you put down the book or leave the cinema, the rule is you don't take the pretense with you.

Performance is generally taken to be a temporary state; the assumption about a pretentious person is that their pretension is bookended by a time before, when they were truly themselves, and a time after, when they will give up their silly act. If pretending, or rather, performing, is part of what we all do each day, then how can we tell when a person is putting it on? When is an actor at work? Is it only in front of the camera or on stage? Is there a point at which we cannot identify the actor's work, when we cannot see the performance? We admire the actor's ability to conceal all effort in portraying

their character, yet paradoxically, we still recognize that it is acting we are watching.

The artist David Levine has a deep interest in this paradox. "To the extent that people are identified with their jobs," he argues, "the actor poses a real social problem; how can you ever trust someone whose job is to be a fake person? And yet, how can you give up on your unquenchable need for entertainment?" For Levine, a core question is: "Do we mistrust mimesis in general, or actors in particular?"

Levine shines a light on the point where performance stops and work begins. His *Bauerntheater* ("Farmer's Theater") involved an actor rehearsing extensively to perform the part of a farmer in Heiner Müller's 1961 play *Die Umsiedlerin* ("The Resettler Woman"), but instead of performing the play, he spent thirty days planting potatoes in a field in Germany; Strasberg's Method reverse engineered, the play translated back into life. *Habit* was a short half-hour melodrama performed on loop, for eight hours a day, by two groups of trained actors working in shifts. The audience could come and go as they pleased, walking around the perimeter of the replica house in which all the action was set. Once the play's plot twists became familiar, focus shifted onto how the actors coped with the repetition, or practical issues, of the performance. *Habit* foregrounded the repetitious work of the jobbing actor, putting a new spin on "going through the motions." For *Private Moment,* Levine worked with groups of actors to reenact short scenes from films shot in New York's Central Park, which they played out repeatedly in their original location but with no signposting to passersby that they were watching a performance. A scene from *The Royal Tenenbaums,* for instance,

involved an older couple, dressed as the characters played by Gene Hackman and Anjelica Huston, chatting and strolling around a small lake. For *The Out-of-Towners*, a couple bickered at the entrance to a pedestrian underpass; only their slightly dated clothes suggested something was not quite right. A jogger wearing a dark hoodie and baseball cap, running the circumference of the park's reservoir, might have been like any other New York jogger, but was a professional long-distance runner employed to play the part of Dustin Hoffman's character from *Marathon Man*.

"Actors are people who have the technique to seem realistic under phenomenally artificial circumstances," says Levine. "Civilians, who always perform convincingly in their daily lives, tend to freeze up in a spectacle." Levine is interested in acting so masterful that it blends into its surroundings. "The thing about work, which acting makes excruciatingly clear, is that the more skillfully you do your job, the less anyone knows you're doing it. I would say my work is about examining aspects of job performance that are so virtuosic as to remain invisible."

Levine uses the example of *la perruque*, or "the wig," an idea explored by the philosopher Michel de Certeau in his book *The Practice of Everyday Life*:

> When you are at work and you are doing everything to look busy, but you are not actually busy. You are actually surfing the Internet, but you look busy: that's *la perruque*. When a client is yelling at you and you mentally go elsewhere and revert to a customer-service script, that's also *la perruque*. It's a performance you

have to give, because you authentically need to not be working at that very moment. So instead of working at work, you work at performance. Our culture demands total transparency, at the same time that it demands near-constant performance. So how can you know a person?

This same question gripped sociologist Erving Goffman, who in 1959 wrote *The Presentation of Self in Everyday Life.* In this study of social psychology, Goffman used the metaphor of the theater to describe how people behave and interact with each other. "On stage" is your acting self, the performer, which is your best side—the one you present to friends, family, and work colleagues. But we also have a "backstage," where we keep our worries and anxieties, where we prepare before going out in public, where we might even play out different, "private," versions of ourselves. It takes "deep skill, long training, and psychological capacity to become a good stage actor," says Goffman.

But this fact should not blind us to another one: that almost anyone can learn a script well enough to give a charitable audience some sense of realness in what is being contrived before them. And it seems this is so because ordinary social intercourse is itself put together as a scene is put together, by the exchange of dramatically inflated actions, counteractions and terminating replies . . . All the world is not, of course, a stage, but the crucial ways in which it isn't are not easy to specify.

Sex, age, race, clothing: these all help establish social status. People's behavior gives us a conscious or unconscious heads-up about how a given situation is going to play out. In general, we expect a consistency between a person's appearance and their manner—it's one of the basic assumptions used in navigating daily social situations. "Pretension" is a word we use to describe an inconsistency in these appearances. Goffman is interested in situations in which there's a marked discrepancy between the impression a person might be trying to convey and the reality of a given situation.

> If we grudgingly allow certain symbols of status to establish a performer's right to a given treatment, we are always ready to pounce on chinks in his symbolic armor in order to discredit his pretension. . . . Sometimes when we ask whether a fostered impression is true or false we really mean to ask whether or not the performer is authorized to give the performance in question.

The power of a performance is partly a question of audience faith, of willingness to believe that a person is who they say they are, accepting that they're not putting it on. In certain situations a person's legitimacy can be easily verified— you can ask to see a professional license, or a uniform might clearly signal authority. But in more subjective contexts— claiming to have met someone, having opinions about art— it's harder to establish how much you should trust one's actions or words. (Note that the fear of being given a position of responsibility by accident or luck rather than achievement,

a common anxiety people have about their jobs, is called "imposter syndrome.")

A word often used to describe an actor's performance is "convincing." When a film critic watches a heist movie and describes the actor playing the lead bank robber as "convincing," what is the critic convinced of? Do they have experiences in the criminal underworld that they can draw upon to verify the convincingness of the actor's portrayal? Or is it a set of established cinematic genre codes that they're responding to, and which the actor successfully checks? In life, as on screen, to be convinced by a performance is to have expectations confirmed. The pretentious is often what is unfamiliar.

People get uneasy when the reliability of ready reckoner such as clothing, bodily gesture, vocabulary, and voice are thrown into doubt. Between 2002 and 2015, the artist Tyler Rowland conducted a thirteen-year experiment in living called *Artist's Uniform* for which he adopted an eclectic array of appearances or personae for a given period of time. He "became" the artist Gustave Courbet for three months, wearing a beard, frock coat, beret, drinking heavily, and regularly visiting "his" retrospective exhibition that was then on at New York's Metropolitan Museum of Art. For one year he wore only clothes bought for him by friends, and for another twelve-month period he dressed as a zebra, sporting a mohawk and wearing black-and-white striped clothing. The project began with *Artist's Uniform #1: The Year I Dyed All My Clothes Pink.* Rowland described the extreme reactions he would get on the street, dressed head to toe in pink. "I bet a woman made you do it." "Fucking homo!" "You

are the coolest person I have ever met." Rowland—who had enjoyed dressing up since childhood, and so did not consider it to be "out of character" to pursue the project—was interested in how clothing keeps a person in character, in how a uniform as opposed to a costume signaled a vocation or commitment on the part of the person wearing the clothes. *Artist's Uniform* was a way of throwing conventional attitudes to appearance into relief.

As with clothing, the moment a person opens their mouth, their accent conditions attraction, power, and trust. When Margaret Thatcher became the British Prime Minister in 1979, on the advice of Gordon Reece—a television producer turned political strategist—she famously altered her shrill tone of voice to a slowly articulated and deeper register, under the tutelage of a coach from the National Theatre. Britain, although a relatively small country, has a wide variety of regional accents all of which come loaded with cultural connotations to do with education, migration, and economic mobility. (Surveys have shown that UK call center operators with Scottish accents are more likely to be thought of as "trustworthy" than those with accents from other parts of the country.) In the US, accents are not assigned status values to quite the same degree as they are in Britain. A strong Bostonian or Texan accent might carry cultural associations, but it doesn't equate with education or money in the same way it does in the UK. Nobody in the US cares how you speak if you're richer than Croesus.

A personal observation. Brits like me living in the US can speak the native tongue but the context shapes its delivery and reception. Americans might take the English accent a

variety of ways; as charming, intelligent, and sexy, or cold, snooty, and even villainous. On more than one occasion, an American has told me that an English accent is read as "pretentious." The idea that a person's natural way of speaking is "fake"—presumably in relation to a US accent being "real"—is absurd, suggesting deeper anxieties about social status and national stereotypes. Some British expats maintain their accents, while some retune their voices to local US idioms and speech patterns. They slip and slide around words, perhaps borrow the "up-speak" cadences of California valley girls. Comical though it can sound, variations in pronunciation are often practical; it's simply easier to make yourself understood in the US if you say "tom-ay-to" rather than "tom-ah-to," or "ward-uh" instead of "waw-ter." It's a question of immersion too; if you hear a song enough times on the radio, sooner or later you're going to start humming it to yourself. Accent modifications evolve slowly through acclimatization rather than putting on a show. Insular English-language speakers praise each other for having a "good accent" when they talk in another language and make the effort to sound like a local, but mock those who change their accent to suit the way English is spoken in another country.

Changing accents is a way of code-switching, leapfrogging from one role to another. His Satanic Majesty Mick Jagger, the middle-class boy from Dartford who became one of the twentieth century's most iconic rock stars, notoriously used to change his accent depending upon whom he was talking with. Jagger dropped his aitches, slurred, and drawled as if he were a bluesman from the American south,

or a salt-of-the-earth English working-class lad made good, if the occasion demanded. He would, reportedly, adopt a rough East London brogue for the Stones' road crew, or a clearly enunciated middle-class accent when giving interviews to members of the British establishment press. As fellow Rolling Stone Ronnie Wood reputedly said, Jagger is "a nice bunch of guys."

Jagger's disturbingly fluid personality is allegorized in Donald Cammell and Nicolas Roeg's 1970 film *Performance*, in which he plays a reclusive rock star named Turner, holed up in a shabby West London mansion with his two lovers. Chas, played by James Fox, is a working-class gangster on the run after a hit went wrong, hiding out at Turner's house while he waits for the heat to cool. Chas is suspicious of Turner's dissolute lifestyle and the atmosphere of rancid glamour in the house, but a steady diet of sex, drugs, role-play, and isolation from the outside world brings him under Turner's influence, until eventually his mind is broken, and Chas's identity becomes indistinguishable from Turner's. Seven years earlier, Fox starred in Joseph Losey's chilling film *The Servant*, which can be read as a kind of prequel to *Performance.* Fox plays Tony, an arrogant upper-class bachelor, recently returned from a spell abroad. He hires a servant to live with him in his large London house, the camp and calculating Barrett—played by Dirk Bogarde—who moves in and begins a systematic campaign of psychological war against Tony, until the young aristocrat breaks down and Barrett becomes master of the house. Both *The Servant* and *Performance* acknowledge the pretense and role-play involved in day-to-day life, warning against "finding out what

it would be like to be otherwise" rather than celebrating it. The pompous trust-fund kid brutally stripped of his assumed privileges and the working-class tough turned poly-perverse stoner: these stories get to the core of what makes pretentiousness such a neuralgic topic—class.

[Opening Scene: A sitting room straight out of D. H. Lawrence. Mum, wiping her hands on her apron, is ushering in a young man in a suit. They are a Northern couple.]

MUM: Oh Dad . . . look who's come to see us . . . it's our Ken.

DAD: *[Without looking up]* Aye, and about bloody time if you ask me.

KEN: Aren't you pleased to see me, father?

MUM: *[Squeezing his arm reassuringly]* Of course he's pleased to see you, Ken, he . . .

DAD: All right, woman, all right. I've got a tongue in my head—I'll do talkin'. *[Looks at Ken distastefully]* Aye . . . I like yer fancy suit. Is that what they're wearing up in Yorkshire now?

KEN: It's just an ordinary suit, father . . . it's all I've got apart from the overalls.

[Dad turns away with an expression of scornful disgust.]

MUM: How are you liking it down the mine, Ken?

KEN: Oh it's not too bad, Mum . . . we're using some new tungsten carbide drills for the preliminary coal-face scouring operations.

MUM: Oh that sounds nice, dear . . .

DAD: Tungsten carbide drills! What the bloody hell's tungsten carbide drills?

KEN: It's something they use in coal-mining, father.

DAD: *[Mimicking]* 'It's something they use in coal-mining, father.' You're all bloody fancy talk since you left London.

KEN: Oh not that again.

MUM: He's had a hard day, dear . . . his new play opens at the National Theatre tomorrow.

KEN: Oh that's good.

DAD: Good! Good? What do you know about it? What do you know about getting up at five o'clock in t'morning to fly to Paris . . . back at the Old Vic for drinks at twelve, sweating the day through press interviews, television interviews, and getting back here at ten to wrestle with the problem of a homosexual nymphomaniac drug-addict involved in the ritual murder of a well-known Scottish footballer. That's a full working day, lad, and don't you forget it!

—*Monty Python's Flying Circus* (1969)

Calling a person pretentious can be a way of calling out the trappings and absurdities of power. It's a way of undermining the authority that they have positioned themselves with. It is also a way of warning them not to get above their station. Used as an insult, it's an informal tool of class surveillance, a stick with which to beat someone for putting on airs and graces. Where the word "pretentious" differs from "pretending" is that it carries with it the sting of class betrayal, especially in the UK, where class is a neurosis as much as a set of social conditions. If being authentic is considered a virtue—what we should strive to be in society—then being pretentious is considered a cover-up, a face-palm to your background. The horror that class migration evokes in people is almost tribal, as if it is a disavowal of your family

and friends. To suggest a person is pretentious is to say they're behaving in ways they're not qualified for through experience or economic status. It is a term of abuse, a treacherous snobbery. Pretension is tied up with class, which is not just a question of money and how you spend it. Class is about how your identity is constructed in relationship to the world around you.

In the Victorian music halls of nineteenth- and early twentieth-century England, satirizing pretension was popular entertainment. The song "Burlington Bertie," written in 1900 by Harry B. Norris and sung by Vesta Tilley, lampooned the life of a lazy young aristocrat spending the family money and carousing around town. "Burlington Bertie's the latest young jay / He rents a swell flat somewhere Kensington way / He spends the good oof that his pater has made / Along with the Brandy and Soda Brigade." In 1915, "Burlington Bertie" spawned a parody song called "Burlington Bertie from Bow," written by William Hargreaves and performed by Ella Shields. In the music hall, working-class posers came in for particular attack. Hargreaves and Shields's song served as a warning. Bertie, from working-class Bow in the East End of London, is mocked for playing posh: "I'm Burlington Bertie, I rise at ten-thirty / And saunter along like a toff / I walk down the Strand with my gloves on my hand / Then I walk down again with them off / I'm all airs and graces, correct easy paces / Without food so long, I've forgot where my face is / I'm Bert, Bert, I haven't a shirt / My people are well off you know."

Somewhere along the class spectrum between Bertie the toff and Bertie the wannabe-toff was "the swell," a fashionable, cocksure young man from the lower-middle-class clerical

professions, who, like the "gent"—another term used by young clerks to describe themselves—spent his money looking sharp and chasing the high life. (In certain senses, the dandyism of the swell and the gent were precursors to the mods of the 1960s.) The performer George Leybourne popularized the song "Champagne Charlie" in 1866 and was to become the embodiment of the swell. "The way I gained my title's / By a hobby which I've got / Of never letting others pay / however long the shot; / Whoever drinks at my expense / Are treated all the same, / From dukes and lords, to cabmen down, / I make them drink champagne."

The music-hall swell could switch between parodying the moneyed classes and providing a role model for his working and lower-middle-class audiences. The swell and the gent were symbols of social progress but just as easily mocked for their aspirations. As one particular rejoinder to "Champagne Charlie" went: "To hear them praise the sparkling wine / It makes a man severe / When they know they cannot raise the price / Of half a pint of beer."

Fears of pretension can result in stunning acrobatics of self-perception. In her book *Class, Self, Culture,* sociologist Beverley Skeggs points to a 1999 academic paper titled "The Ambiguities of Class Identities in Contemporary Britain," in which the middle-class individuals surveyed for the report expressed "a strong desire to be read as 'ordinary.' This suggests a desire not to be read as pretentious, demonstrating awareness of, and a way of evading, hierarchy and privilege in relationships to others." In a 2002 MORI poll, 55 percent of those in middle-class occupational categories claimed to have "working-class feelings." To be perceived as "ordinary"

is to distance personal responsibility from bigger questions of inequality. If you are playing fair in your ordinariness, then you're not part of the problem.

To accuse someone of pretentiousness, of trying to stand out, affirms the fact that you fit in with everyone else. Because pretension is measured against the baseline "norm" of the accuser, there is an assumption that pretension always involves scrabbling up the class ladder. (Ghosts, perhaps, of pretenders to the throne and their claims to privilege and power.) Pretension is taken to be synonymous with snobbery. In his 1848 satire *The Book of Snobs*, William Makepeace Thackeray wrote: "Snobbishness is like Death in a quotation from Horace, which I hope you have never heard, 'beating with equal foot at poor men's doors, and kicking at the gates of Emperors' . . . An immense percentage of Snobs, I believe, is to be found in every rank of this mortal life." True, pretension and snobbery can be found everywhere, but snobbery is different. It is a form of refined arrogance, a social ambitiousness deeply invested in the opinion of others. The snob thinks they are better than those beneath them. The inverted snob thinks their ordinariness makes them more virtuous than those with a higher social status. "Snobbery, like religion, works through hope and fear," as the essayist Joseph Epstein puts it. Snobs want to be accepted by the social bracket they aspire to—up or down—and are perpetually terrified of being rejected by it. Snobs are self-aware, conscious that they're being watched, whereas a pretentious individual isn't necessarily motivated by the opinions of others. A person might do something out of sheer enjoyment or creative fulfillment, unaware or unbothered that others consider them ridiculous and pretentious (what Orson Welles would call "the

confidence of ignorance"). Pleasure might be derived from the activity itself, rather than from what others think of the activity. Often it can be the circus that surrounds something that is snobbish, not the thing itself. Take wine, for instance; there is nothing intrinsically snobbish about it as a substance. But it's easy to ridicule the snobbery of wine experts and the purple language used to describe what they're tasting.

Claims to ordinariness and salt-of-the-earth virtue—"slumming it," as it's crudely called—are themselves pretentious. The assumption that dropping your aitches or asserting a love of a cheap beer over a fine wine, or processed cheese over a Parmesan, will make you seem unspoiled or somehow more gritty is classic downwardly mobile play-acting. In their 1995 anthem "Common People," the band Pulp nailed the stereotype of the middle-class artist pretending to be working class: "Rent a flat above a shop / Cut your hair and get a job / Smoke some fags and play some pool / Pretend you never went to school / But still you'll never get it right / 'Cos when you're laid in bed at night / Watching roaches climb the wall / If you call your dad he could stop it all." (Only in the UK would a band be able to have a Top Ten hit with a song about class dissimulation.) Anti-intellectualism is a snobbery just like anti-pretension; the anti-intellectual is often anxious not to be marked as part of an educated elite, the kind of person that they suspect uses ideas and language to maintain a position of power. Prolier-than-thou pretension is insidious; it perpetuates a received idea of what "normal" is. The privately educated artist putting on the act of being a blue-collar worker—changing accent, hiding intellectual or artistic interests in order to play to an insulting

stereotype of working-class culture as a place where creative, imaginative, and intellectual pursuits exist only in the most unselfconscious ways—simply reaffirms class prejudice.

Questions of race, sexual orientation, and gender turn inside out ideas of what "ordinariness" is. As many discussions of transgender politics or racial identity flag up, actions and attitudes are conditioned by social constructs, by expectations that people behave in certain ways. To measure the "authenticity" of others by socially established norms is pointless. Myriad life stories in the world productively complicate any idea of a norm existing in the first place.

Made in 1990, Jennie Livingston's contentious documentary *Paris Is Burning* follows the participants and organizers of drag balls in late 1980s Harlem. At these balls, young, often homeless, gay, black, and Hispanic men, who belong to competing "houses," walk or dance in front of a panel of judges who award points for their moves and, in certain categories, for "realness." Realness is the authenticity of each contestant's appearance, how convincingly the participant manages to pass themselves off for a member of the straight world. *Paris Is Burning* documents the complex sets of categories in the balls, ranging from conventional drag queen roles through to "executive realness" (or "Wall Street," in which the participant dresses like a businessman or woman), "preppy realness" (also know as "Town & Country"—a smart-casual Ivy League student look), "military realness" (army parade uniform), and "banjee realness" (an excessively macho street look).

"Realness" is a standard by which a complex form of pretension is measured. It's both aspiration and satire. "Realness" emphasizes difference, shows how mainstream identities

are themselves an act, not a fact of nature. *Paris Is Burning* reaffirms all that Goffman observed, in *The Presentation of Self in Everyday Life,* about the daily performances of white America. "By looking good, one can feel good. By looking powerful, one can feel powerful. One can be powerful. Therefore beauty begets control. Artifice equals power," says one member of the House of Diabolique. As drag queen Dorian Corey explains in the film, "to be able to blend, that's what realness is. If you pass the untrained eye—or even the trained eye—and not give away the fact that you're gay, that's when it's realness." Lucas Hilderbrand has observed how the categories of realness shown in *Paris Is Burning* shift between those materially out of reach to the participants, and those much closer to home, such as the military look and banjee, or what Junior Labeija, the ball MC, describes as "looking like the boy that probably robbed you a few minutes before you came to Paris's ball." Hilderbrand writes:

> The Military category is striking not because it presents a forum for performing the most rigid forms of masculinity (which, not coincidentally, emphasizes presentation and costume) but also because it is one of the most working-class categories. A career in the military has long been one of the primary options for young men, particularly economically disadvantaged men of color, to achieve financial security and class advancement.

Paris Is Burning is a rich document of vogueing, the ball dance style. This grammar of intricate, symmetrical hand movements, angular arm gestures, squats, spins, feints, and

falls was originally derived from the poses and moves of catwalk models and photo spreads in *Vogue*. Madonna, queen of pretension, infamously appropriated vogueing wholesale from drag ball dancers. She subsumed one form of pretension—that which bound a marginal social community together—beneath another: pop music's license to pretend to be something you're not. A set of moves that had its origins in high fashion imagery was transformed underground and then pulled back out to once again serve the industry of glamour and celebrity.

Far more crucially, *Paris Is Burning* is a window into lives shaped by chronic structural racism, transphobia, and homophobia. It describes forms of alternative family kinship, of the balls as safe spaces, and documents a number of tragic individual stories. Critics were divided when the film was released—as they remain today—many focusing on the fact of Livingston's own privilege as a white, middle-class filmmaker, and the contrasting ways in which the film was received by white and black audiences, straight and gay. Some held that the film perpetuated the idea of white society as the dominant one, that it further made the film's subjects appear to be "other." (One argument being that imitating what you're criticizing ends up reinforcing its power; by saying that it needs to be attacked you're reaffirming that it's the dominant system.) Debates raged around who had the right to represent and interpret the ball community, especially cross-racially. Through whose eyes was the idea of "realness" constructed; those of the participants, the filmmaker, or the film's audiences?

By applying the idea of pretentiousness to the context of these vogueing balls—of "finding out what it would be like to

be otherwise," of aspiration, of changing the here and now with whatever tools are available to you (dress, attitude, a community of people with similar desires and needs)—it's possible to see how fraught and complex pretension is. In this context, to accuse a person of pretension is a refusal of permission for that person to construct their own identity, a process that may well be true to how they see themselves. To demand they be "authentic" to their social circumstances is a form of social control. Decry pretense and you not only deny the possibility of change, you remove a tool of social critique from the hands of communities that need them.

Of course, not all social groups share the same criteria for judging each other. In his 1963 book *Outsiders: Studies in the Sociology of Deviance*, Howard S. Becker analyzed the social worlds of marijuana users and jazz musicians. Becker had worked in Chicago as a jobbing pianist while studying for his PHD and observed up close how the subculture of jazz players shaped itself in opposition to "square" society. Through those experiences Becker came to understand that "deviance" could only be understood in relation to a set of rules being violated, and the social group that maintains those regulations. "Deviance is not a quality that lies in behavior itself, but in the interaction between the person who commits an act and those who respond to it." Deviance, like pretentiousness, is in the eye of the beholder, in the gap between one individual's baseline of acceptable behavior and the actions of another. The conservative who brands someone a "deviant" for their appearance or lifestyle choice is trying to maintain a particular set of rules in which they have an emotional investment. When a furious reviewer slams a

book for being pretentious, they're essentially angry because it deviates from the aesthetic standards or worldview they've chosen to subscribe to.

Arguing about rules, regulations, and right or wrong ways of doing things is another way of talking about the amateur and the professional, social categories that make pretentiousness an even knottier issue. The professional is licensed—by training, title, money, time spent—to work in a particular field. They can avoid the charge of pretension because they work in an official capacity. The amateur, on the other hand, might only do a certain thing at weekends or in the evenings, often for free and out of enthusiasm. The amateur doesn't have the right credentials; trying to do what the professional does might open them to accusations of being pretentious, of stepping above their station. But the amateur is also free to operate outside the paths of protocol that training has set in the professional, beyond the reach of establishment codes. The amateur can make the professional appear pretentious; think of the corporate chain restaurant that masquerades as a traditional British pub, French bistro, or southern-style BBQ joint—the downwardly mobile pretension of the professional operator. Every professional starts out as an amateur, only gradually sliding along a spectrum of experience toward a position of paid expertise. And everyone is an amateur at something or other: the lawyer who plays five-a-side soccer on a Sunday; the nurse who takes salsa classes once a week; me, the magazine editor who dabbles as a musician.

Pretension is a question of optics. The pessimist sees pretension as a sham. The optimist views it as innocent, tragicomic, an excess of effort. Like watching amateur actors in a

local village play, a wooden or overambitious performance might not be deliberate. It could be deeply sincere; the am-dram troupe putting everything they've got into their production. Pretentiousness resides in someone's lack of awareness that their ambition might exceed their capability, or inability to laugh about one's own limitations. (What often lurks behind pomposity is a sad insecurity.) In this sense it relates to what Susan Sontag defined in her essay "Notes on Camp" as "the sensibility of failed seriousness, of the theatricalization of experience." She quotes Wilde's line from *An Ideal Husband* that "to be natural is such a very difficult pose to keep up." Camp, for Sontag, is "a love of the exaggerated, the 'off,' of things-being-what-they-are-not." Camp is the ill-fitting mask worn by the actor, the failure of illusion, but—unlike Brecht's theater, where this is deliberately flagged up—the performer is unaware that the mask has slipped. To appreciate camp requires generosity and empathy. Its pretensions can almost provoke a feeling of melancholy, a recognition that something amateurishly produced might be made with the best of intentions. Whatever its failings may be, it comes from the heart. This is to be celebrated, not trashed.

Sontag holds that camp reveals itself as things age. "When the theme is important and contemporary, the failure of a work of art may make us indignant. Time can change that. . . . Thus, things are campy, not when they become old but when we become less involved in them, and can enjoy, instead of be frustrated by, the failure of the attempt." Accusations of pretentiousness fade the older something becomes. As works of art or styles of dress recede into the past, the historical forces

that shaped them become legible. Familiarity lets us regard them fondly.

There's a sketch by comedians Stephen Fry and Hugh Laurie in which two jaded critics moan about the standard of Fry and Laurie's own television show. "Simon Flituris, you saw that sketch . . . I assume you were disappointed?" asks the first critic. "Yes I thought it was predictable really," answers the second. "You predicted it, did you?" "Yes, I predicted it." It's a parody of sophisticated ennui, a shot fired at the overeducated and undercurious, but the sketch also implies that anxiety about pretentiousness derives from a fear of the unfamiliar and unpredictable. As artist Will Holder has noted, "It was difficult for the Cubists to make work as they didn't have, as we do, the example of Cubism to help them." Scientific studies of music appreciation, for example, have demonstrated that musical preferences are tied up with familiarity. Neuroscientist Daniel J. Levitin explains:

> When a musical piece is too simple, we tend not to like it, finding it trivial. When it is too complex, we tend not to like it, finding it unpredictable—we don't perceive it to be grounded in anything familiar. Music, or any art form for that matter, has to strike the right balance between simplicity and complexity in order for us to like it.

You have your established schema for what a work of art should be, and then something alien arrives and throws that schema into doubt. A gap opens up between your expectations and what you're presented with, leading you to question

the legitimacy of the new thing that has arrived, to ask who gave this upstart the authority to exist in the first place. You are either "convinced" by it, because it agrees with criteria familiar to you, or you call it pretentious. It's worth noting that the word "convention" originally meant a coming together or assembly of people. To break from the convention is to shun other people, flip the bird at the group consensus.

Attitudes change. Eventually the so-called pretender's work finds itself in the canon of Important Works of Art, and the folk devil becomes the icon of rebellion, celebrated for sticking it to The Man. The works of post-impressionist painters, regarded in their day as difficult and radical, are today reproduced on table mats, tote bags, and posters hung in dentist waiting rooms. Musician David Bowie recalled that "in the 1960s nobody thought I would be successful, because I was too avant-garde." Today, Bowie is a British national treasure, with museum exhibitions and entire evenings of BBC TV dedicated to his career.

"In an expanding universe, time is on the side of the outcast. Those who once inhabited the suburbs of human contempt find that without changing their address they eventually live in the metropolis." Despite his observation, Quentin Crisp did change his address, leaving the decades of homophobic abuse he'd suffered in London for New York in 1981. For those that stay, what is life in that metropolis like, once it's sprawled beyond your once contemptible suburban home?

> Start with externals, and proceed to internals, and treat life as a good joke. If a dozen men would stroll down the Strand and Piccadilly tomorrow, wearing tight scarlet trousers fitting the leg, gay little orange-brown jackets and bright green hats, then the revolution against dulness which we need so much would have begun. And, of course, those dozen men would be considerably braver, really, than Captain Nobile or the other arctic ventures. It is not particularly brave to do something the public wants you to do. But it takes a lot of courage to sail gaily, in brave feathers, right in the teeth of a dreary convention.
>
> —D. H. Lawrence, *The Evening News*, September, 27, 1928

To live in major cities in the West is to be surrounded by claims to authenticity. We're encouraged to look for the real deal, and not get seduced by the ersatz bloom of pretension. Authenticity is a form of authority; a legitimacy of speech, dress, action. It promises a ticket to the truth. Shops, restaurants, real estate, and a range of leisure activities all promise the bona fide, the genuine, the real McCoy. Being authentic is a virtue and buying into it is a demonstration of financial shrewdness.

In 2015, a billboard advertising hair-styling products in London's Shoreditch neighborhood declared that "Pretense Is an Offence." It's a ham-fisted appeal to a nonexistent link between youth and creative authenticity, ignoring the fact that many large cities are theaters of pretension. In his book

Soft City, Jonathan Raban noted how urban life "is a life lived through symbols." Here "we are barraged by images of the people we might become. Identity is presented as plastic, a matter of possessions and appearances." Buildings imitate architecture from past eras or other parts of the world. Shops and restaurants strive to evoke emotional atmospheres based on historical periods—from back when life was honest and true—to promise an experience in excess of the goods on offer.

Marketing lures consumers—particularly urban, middle-class ones—with games of linguistic pretense. The "home-made," the "natural," the "organic," and the "farm-raised" play on fantasies of our own ecological responsibility in the food we buy, or nostalgia for meals just like your mum probably never made. The natural and organic possess a kind of earthy authenticity, or do the job of stand-ins for other cultures. (In a New York branch of Whole Foods I once saw white asparagus described on the store label as "preferred by Europeans," as if to suggest that buying it would confer both nutritional value and an appreciation for some misty notion of European sophistication.)

Pretension is a name game, in which you can hear the echoes of Orwell's "Politics and the English Language." Look at the sizing terms used by Starbucks—*grande, venti, trenta*—designed to make you think of Milanese coffee bars rather than the grim airport terminal in the Midwest that you're stuck in. Think of the exotic and romantic evocations named by perfumes and aftershaves—Oriental Lace, Euphoria, La Nuit de L'Homme, Midnight Poison, Possession—or the dog-Latin names that businesses and health-care providers give

themselves for ersatz gravitas. Verizon, Protiviti, Diageo, Novartis, Celera, Hospira, Aetna: these are names designed to make you think of venerable institutions whose company headquarters have neoclassical facades and wood-paneled offices filled with leather-bound encyclopedias, not bland glass-and-steel buildings in out-of-town business parks.

Car names provide deliciously absurd examples. Ford Aspire, Evolve Volvo, Citroën Picasso, Lincoln Navigator, Honda Element, Austin Allegro, Oldsmobile Starfire, Toyota Highlander, Jeep Renegade, Buick Wildcat, Ferrari Testarossa, Porsche Cayenne, vw Scirocco, Dodge Charger, Chevy Cavalier, Plymouth Fury Golden Commando, Vauxhall Tigra, Kia Picanto, Renault Captor, Mitsubishi Shogun. Aspire, evolve, or play commando. The names are patently ridiculous. Will you become a feudal Japanese general as you do the school run behind the wheel of a Shogun? That's for you and your grip on reality to decide, but these pretenses speak of the powerful lure of lifestyle, of chasing proximity to happiness or prestige (though not in the case of the workaday Shogun).

The original meaning of the word "prestige" was "illusion" or "conjuring trick," from the Latin *praestigium*—a delusion. The delusion is in ever-deferred promises of personal betterment through acquisition. It's there in advertising campaigns that use the radicalism of a previous era in order to market the products of today—the absorption of transgression and dissidence into just more categories of consumer values. "Because you're special." "Because you're worth it." Aspiration is the sense of dislocation between our present state and what we hope will make life easier, more tolerable. To close this gap, we play roles that might help us feel we are

living a more ideal life. We might close that gap with a hobby, the way we present ourselves on social media, or a way of dressing, or in the food we eat. Pretentiousness defines a degree of dislocation between our circumstances and the image we are trying to project.

In "Post Modern," an essay written for *Harpers & Queen* in 1980, Peter York describes London that year as a place where

> the time frames are utterly scrambled, the past is all around: in that world the notions of either rejecting or embracing the past look irrelevant. Post-Modernism, which deals with the past like one huge antique supermarket, looks very relevant indeed. Pastiche and parody is just an uncomfortable transition to a time when period references will be used without any self-consciousness.

The age of the antique-modern supermarket sweep arrived with us many years ago. Look around you. Western cities are what artist Simon Martin has described as "a generalized environment of quote, reference, and approximation, a place of perpetual refurbishment and all-purpose vernacular." The sociologist Sharon Zukin, in her book *Naked City: The Death and Life of Authentic Urban Places,* observes in cities such as London and New York "a trend toward an aesthetic rather than a political view of social life." Tattoos and a Crass band T-shirt no longer, as they once did, mark you out as a person committed to the principles of a radical lifestyle—living in a squat, becoming vegan, rejecting the comforts of convention in order to pursue an alternative vision of society.

The westerner who knows the difference between soba and ramen noodles is not necessarily an adventurous traveler, conversant in the cuisine of East Asia. This knowledge can instead be an ostentatious display of tolerance for cultural difference. That Korean bibimbap or "proper" British fish'n'chips—preferably ordered in a mockney accent—may taste good but it doesn't make you a better human being.

White, middle-class lifestyle consumerism is both an upwardly and downwardly mobile set of privileged fantasies. It maintains a panoptic, 360-degree watch on culture past, present, and future. Neighborhoods are gentrified on the promise of a creative lifestyle, on proximity to the trappings of bohemian pretension, to good coffee and tastefully arty loft living. In New York in the early 2010s, fantasies of Prohibition-era America were paired with 1950s cupcake domestic kitsch. Here it was possible to observe unremarkable young men act out fantasy versions of the early twentieth-century New York rag trade: handlebar mustaches, tailored white shirts, suspenders, full-sleeve tattoos, and manly barbershop fades and shaves. Farm-to-table food and fashion made comforting appeals to traditional American homesteading: styling by The Band and *Butch Cassidy and the Sundance Kid*. In that same period, London saw a variation on a theme of postwar austerity: design objects, kitchenware, and food marketed with a self-consciously plain, institutional, or local village shop aesthetic in thrall to a fantasy of historical working- and middle-class domesticity. It was an idealization of a period wrecked by war and economic depression, governed by paternalism and institutionalized sexism and racism. Fashions fade, and the contemporary social conditions that

made past eras seem attractive change, but the mechanisms are not so different to the Victorians and their chocolate-box portrayals of medieval England, or to the 1960s counter-culture's incense-infused infatuation with Edwardian-era aesthetics, or to revivals of 1950s Americana in the 1970s. These are what York calls "antique modern memories," and they appeal to whatever irrational, mystical values we believe each period represents regardless of the historical truth. Fun, perhaps, but it's just gold-plating to cope with the contemporary drudge.

Zukin observes that "authenticity has taken on a different meaning that has little to do with origins and a lot to do with style. The concept has migrated from a quality of people to a quality of things, and most recently to a quality of experiences." Style has always been a question of survival in cities. It is a way of navigating other people and carving your own corner. There is pleasure to be had in playing with it. But there is a serious cognitive dissonance between the effort we put into controlling our image and, at the same time, claiming allegiance to transparency and authenticity.

Walk through the city and observe how people dress, where they eat and drink, the activities they choose to do; watch people demonstrate their cultural literacy, see how they trade in symbolic value. You will see those who like to stand out, to make their individuality and authenticity visible through clothing or behavior. There will be those who won't show off their individualism, for reasons of money or out of fear of violence and hostility, or simply because they are remarkable in other ways they feel don't need to be externally signaled. Some will be dressed according to religious belief

or cultural background. And walking the streets and riding the subways will be people who wish to look like everyone else. Novelist Harold Brodkey suggests a reason for this: "We want to be dressed, and we want others to be dressed somewhat similarly, partly for the democracy of it, and partly so that we are speaking a halfway common language—so that we are not isolated in our own heads . . . but are part of a dialogue about acceptable or exciting appearances." Or, as Holden Caulfield, the adolescent narrator of J. D. Salinger's novel *The Catcher in the Rye*, describes school, it's because life is "full of phonies, and all you do is study so that you can learn enough to be smart enough to be able to buy a goddamn Cadillac some day, and you have to keep making believe you give a damn if the football team loses, and all you do is talk about girls and liquor and sex all day."

Music-related style tribes used to provide identities to inhabit. Mod, Ted, Rocker, Folkie, Greaser, Rude Girl, B-boy, Casual, Indie Kid, Crusty, Goth, Hippie, Skin, Raver, Punk, Emo, Skater, Psychobilly, Metaller. These identities gave shelter, a sense of belonging; being someone else was a way to fantasize your exit from small-town small-mindedness. Not that music has to play any part in shaping the look of a tribe. You could be a Japanese teenager into *kosupure* ("cosplay"— dressing up like characters from comic books, TV shows, or movies), hanging out on the Jingu Bridge in Tokyo or one of a gang of "bros" roaming New York in the summer of 2015, wearing identical oversized beige shorts, button-down shirts, Birkenstocks, and white baseball caps on backwards. Perhaps you are a middle-aged man out on the golf course dressed, like your business colleagues, in a Pringle sweater

and slacks, or one of a group of hiking enthusiasts clad head-to-toe in waterproofs, proud that you and your companions are equipped with the latest high-tech, lightweight, breathable materials. No matter how individual or unpretentious someone may perceive themselves to be, there is a strong desire within people to dress the part, to get the look so as to fit in to a particular social scene. "Like trousers, like brain," said Joe Strummer of The Clash.

As an industry, fashion appears to take itself far too seriously; the money and effort that goes into the circus of shows, advertising, and media representation seems disproportionate to the usefulness of its core products. *Haute couture* embodies, for many, the perpetuation of unrealistic and damaging ideas of physical beauty. It also stands for vulgar excess; obscene amounts of money thrown at inessential baubles and sequins. If excess is your only definition of it, then calling fashion "pretentious" is like shooting fish in a barrel. But looking good—however you and your crowd define it—is a socially acceptable charade and fashion and, if it interests you, can be accessed at any level, from making your own garments to streetwear to high-street chains to designer collections and bespoke tailoring. Wearing smart or beautiful clothes for a special occasion, even if you normally dress like a schlub, attracts compliments. Fashion is culturally omnivorous and dilettantish—in that lies its pleasures and pains. Unembarrassed about an interest in surface, fashion's cyclical structure is a driver of pretense. This built-in obsolescence creates a permanent condition of anxiety or stimulus, depending on how you're wired. Fashion's capriciousness symbolizes change in a world where many have a fear of change.

Social media encourages us to present our best sides, sharing online personal or professional achievements, major milestones. There are some who feel comfortable discussing personal tragedy and failure online, but social media's structures of engagement are rigged toward the positive, tuned to "likes" and emoticon hearts and to convincing the world that all is peachy. Identities have become more liquid; your real-life persona and your various online personalities swill around each other. Anonymity or alternative online names provide a way of protecting political dissidence, evading harassment, or expressing cultural heritage.

And yet identity theft has become a major criminal activity, and opportunities for online pseudonymity have allowed people to behave in abusive ways they would not otherwise face-to-face. On comment threads and online reviews lurk those for whom no creative project or act of criticism is ever quite good enough. "There's always someone, somewhere, with a big nose, who knows," as Morrissey sang on The Smiths' Cemetry Gates. There are the trolls, aggressive voices speaking from what writer Mark Fisher describes as a "lofty, Olympian perspective." Trolls are often the first to call out pretentiousness. They assume a "posture of alleged detachment" and "sneer from nowhere. For what [the troll] disavows is its own investments; an investment in always being at the edge of projects it can neither commit to nor entirely sever itself from." The pseudonymous troll who trashes someone or something for being pretentious is, ironically, themselves being pretentious, holding in front of them a digital mask, a shield of clay.

"Cultural omnivores" are what sociologists call those members of the middle classes who can access, participate

in, know, and feel confident about using a wide range of cultural references—from the popular to the esoteric, from the local to the international. Reams have been written about how, in the early decades of the twenty-first century, the urban hipster became the whipping boy for this omnivorousness. Step out in a vintage Run DMC T-shirt, have lunch at an Ethiopian restaurant, check out an exhibition of Brazilian modernist art, and end the day at a bar styled after a 1920s speakeasy. A genuinely pluralist outlook on life might motivate these interests. They might come from a sincerely held pleasure taken from playing magpie among the shiny detritus of postwar culture. It's a pleasure enabled and rocket-propelled by the internet, by access to information and references that once would have taken more effort to track down, or may have required imagination to fill in the gaps. But it also speaks loudly to privilege; the privileges of education, travel, and leisure time that money allows.

The omnivore in search of authentic kicks is nobody new. In 1966, the writer Richard Fariña published *Been Down So Long It Looks Like Up to Me.* (It was to be his only novel, as he was killed in a motorcycle accident two days after the book was released.) *Been Down So Long* satirizes the emerging counterculture from the front line. The novel is set on the campus of a fictional US Ivy League university, loosely based on Cornell, and tells the story of Gnossos Pappadopoulis, a proto-hippie in search of "the truth" through sex, psychedelic drugs, jazz, politics, travel, and a potpourri of Eastern mysticism and religion. Key to Pappadopoulis's personal philosophy—the guiding principle that gets him into all kinds of absurd scrapes and unpleasant situations—is the idea of

"exemption": "Exemption, baby. Walk among the diseased with Immunity. A little knowledge-in-the-abstract is all. With any luck, a vision every seventh day or so." He believes himself to be exempt from all the rules governing other people's behavior, immune to society's moral codes and at liberty to adopt whatever belief system suits him. Essentially, he always maintains the meta-position, a kind of critical distance, never conceding that his actions could hurt other people.

In 2014, the New York–based collective K-Hole—a group of artists operating in the register of a trend-forecasting group—published "Youth Mode: A Report on Freedom." "Youth Mode" argues that we live in an era of "mass indie," the assimilation of once alternative and independent forms of youth culture into the mainstream, and that personal expression through fashion or music taste no longer carries the subcultural weight it once did. (Fariña's Pappadopoulis is a dinosaur.) One solution to this problem, K-Hole suggests, might be called "normcore," a strategy of assimilation into different communities rather than demonstrating individual self-expression. Fitting in would be the new standing out. Normcore was misinterpreted at the time as a mandate to dress boringly, to wear Gap cargo shorts or nondescript sportswear, but what K-Hole was driving at was an idea of adaptability, of dressing the part depending on the context. Theorist Rory Rowan has pointed out that normcore presupposes an ability to move and be accepted within a range of other communities. Code-switching is a white, middle-class privilege that ignores broader problems of gender, race, and sexuality, factors that make chameleon-like mobility difficult for some. It presumes that problems relating to the sphere of

pop culture—specifically "alternative" subcultures that came out of Western rock and dance music histories—are problems that everyone is equally invested in wrangling with. They are not, and the result is a false consensus effect, a cognitive bias that sees one's own views as typical of many. And so we circle back to the false note of objectivity that the accusation of pretension sounds. Those other people are false because they do not share your values, your worldview. "Exemption, baby. Walk among the diseased with Immunity."

Class, lifestyle, and the judgment of pretension are clearly chained to questions of taste. Pierre Bourdieu's landmark work of sociology, *Distinction,* describes how an individual's social and cultural capital (that is, who you're connected to and what you know) works in tandem with their financial means to determine class status. Your "habitus" is the set of behaviors and dispositions you develop within your social class. These tendencies interact with different "fields," such as the arts, education, and religion, in which we try and advance our social and cultural capital. Bourdieu's contemporary, Howard S. Becker, preferred to call these "worlds," spheres of activity in which many people are trying to achieve different goals but end up working collectively toward those ends. ("It takes a village to write a symphony and get it performed," as Becker put it.) Bourdieu also uses the term "doxa" to describe deeply ingrained concepts we hold about the world; all those things that seem self-evident, common sense, and which might blind us to bigger structural inequalities in society. Your doxa is your baseline against which you measure the fraudulence or truth of other people's efforts. Your taste, your aesthetic dispositions for or against certain foods,

music, art, and so on, is formed in the interplay between all these factors.

If what's pretentious for one person is enthralling for another, is debating pretentiousness simply another way of talking about taste? Only up to a point. If the word "pretentious" is used to define a person or thing operating outside the legitimate borders of class or qualifications, then that's an operation of socially conditioned taste. This dress or that movie is in "bad taste" because it's failing to use the right class codes properly (a virtue if you're film director John Waters, the "Pope of Trash"). Concepts of taste are too broad to fully explain why pretense triggers such strong cultural allergies. A more specific answer might be found in the adjective "sophisticated," which often gets paired with "taste" to describe a refined sensibility or liking for complexity.

"The class politics of sophistication are inseparable from its sexual politics," says Joseph Litvak in *Strange Gourmets.* Litvak points out how

> a glance at the dictionary is all it takes to recall that "sophistication" in fact means "perversion." For though sophistication might nowadays be defined most readily as "worldliness," as the opposite of "naiveté," its older meaning, as well as its normative meaning, deriving from the rhetorical aberration known as sophistry, is "corruption" or "adulteration."

In medieval Latin, the verb *sophisticare* was used in relation to the dishonest tampering of goods, especially food.

At the start of the eighteenth century, the use of "sophisticated" shifted to mean something deprived of a primitive or natural state. "Unsophisticated" meant something genuine but shifted to mean a person who was ingenuous or inexperienced. In the nineteenth century, the idea of something being altered also became associated with wisdom or refinement.

Pretentiousness shares with sophistication a lingering sense of "unnaturalness"; something faked, pretending, tampered with. Litvak presses the idea that sophistication is linked to perversion in the sexual sense, and therefore carries with it a latent homophobic charge. The association of sophistication with a form of urbane and knowing behavior gets reinforced "every time advertising and journalism, loathing as they do the pretentious and the trendy, derisively dangle before their audience the perennially unpopular figure of the snooty (i.e., gay) salesman in the upscale boutique." Pretension implies affectation. People are not acting themselves; rather, their lying urbanity is trampling all over your plain-speaking—and presumably heterosexual—truth.

Music critic Carl Wilson suggests that "mainstream taste [is] the only taste for which you have to say 'sorry.'" The guilty pleasure, that cheesy pop song you secretly like despite your better judgment. An apology would depend on whom you're talking to. Mary Gaitskill, in an essay responding to *Let's Talk About Love,* Wilson's book about taste and the music of Celine Dion, writes that Dion "is just a person making art that [Wilson] can like or dislike, but that his likes or dislikes don't reflect on the fundamental quality of her humanity or his." (The accusation of pretension is often used to

attack a person's "fundamental quality of humanity.") For some, modern art and opera are elitist pursuits, interests that should be played down for fear of being branded a snob, or a person with money to burn. For others, these interests are not cool enough—too academic, stuffy, too close to institutional respectability. For the cultural omnivore, expressing a love for both Ornette Coleman and ABBA demonstrates a refined palette. Having an opinion about the production on a Beyoncé song and tickets to a production of Robert Wilson's *Einstein on the Beach* shows you're at ease with the crowd and the connoisseur alike, that you're not a snob, you've got a cool range of interests. But not everyone uses the currency of cool, and what constitutes its value constantly shifts. If you're singing karaoke, trying to choose a "cool" song to sing might be the most awkward thing you can do in that situation; it's singing the hit everyone can recognize that makes the experience fun. Taste-making is not always a top-down process, administered by the shadowy "cultural elites" that conservatives like to tell ghost stories about. As the history of pop culture since the 1950s has shown, it's just as often been working-class culture that has set the terms for what "cool" is.

[Nigel is playing a soft melody on the piano.]

NIGEL TUFNEL: It's part of a trilogy, a musical trilogy I'm working on in D minor, which is the saddest of all keys, I find. People weep instantly when they hear it, and I don't know why.

MARTY DIBERGI: It's very nice.

NIGEL TUFNEL: You know, just simple lines intertwining, you know, very much like—I'm really influenced by Mozart and Bach, and it's sort of in between those, really. It's like a "Mach" piece, really. It's sort of . . .

MARTY DIBERGI: What do you call this?

NIGEL TUFNEL: Well, this piece is called "Lick My Love Pump."

—*This Is Spinal Tap* (1984)

Pop music has never asked anyone for permission to be pretentious. It has joyfully complicated the terms of pretension. It is built into pop's DNA, even when it shouts loudest about its authenticity. Flashback to Eno: "My assumptions about culture as a place where you can take psychological risks without incurring physical penalties make me think that pretending is the most important thing we do. It's the way we make our thought experiments, find out what it would be like to be otherwise."

Eno can get away with pronouncements like this precisely because his career is a successful experiment in pretension. In

the 1970s he practically invented the idea of the rock star as erudite polymath, cutting a deeply pretentious figure across the pop landscape. As keyboard player in the band Roxy Music—a band with an acute eye for collaging a wide range of American pop influences into their look and sound—he played the androgynous libertine, an alien sex fiend dressed in feather boa, makeup, and stack heels. His style enabled people to safely bracket him as eccentric; at the same time he occupied the role of intellectual studio boffin, happy to engage in conversation about John Cage or cybernetic theory. Eno gave his solo albums ambitious-sounding titles such as *Taking Tiger Mountain (By Strategy)* and *Before and After Science* and published the "Oblique Strategies," a set of 115 cards—like a low-maintenance I-Ching—designed to suggest ways out of a creative block with instructions such as "Try faking it," "Don't be frightened of clichés," and "Honor thy mistake as a hidden intention."

On the cover of the 1973 album *No Pussyfooting,* he appears along with Robert Fripp in a mirrored room that, with its books and esoteric paraphernalia, looks like the study of an interplanetary dandy academic. His clothing is all black—the uniform of artsy pretension—but the hair and makeup still speak of the rock'n'roll excess of his Roxy Music days. A few years later, in 1976, he appears in an evocative photograph with his friend, the artist Peter Schmidt: the two men, both in black and with short-cropped hair, sit at a table covered with a neat, crisp tablecloth. A small vase of flowers and a notebook sit on the table between them, and four prints by Schmidt—simple, haunting depictions of empty rooms—are pinned casually on the wall behind them. The room

is bathed in lambent daylight and evokes a world of slow, scholarly meditation that couldn't seem further from rock's scuzzy glamour and dissolution. You could imagine discussions here over cups of green tea about the Golden Section, a Sunday afternoon spent making watercolors while trying mentally to resolve a particularly complex synthesizer overdub in the studio. It's an image onto which—perhaps to the sound of tracks with titles such as "Events in Dense Fog" or "Dunwich Beach, Autumn, 1960"—you could project a model of pop stardom closer to that of academia or the amateur inventor than to sex, drugs, and rock'n'roll.

The potential to construct yourself in the image of something you're not has been one of the traditional promises of pop music. "Insufferably over-fashionable, lavishly over the top, dreadfully dilettantish, finely eclectic. Pop can be so many things," wrote music critic Paul Morley in 1980. It has always been on its way to somewhere else: dub fused with punk, punk stole from funk, funk adopted rock, rock embraced gospel, gospel joined hands with soul, soul danced along with house. Pseudonyms and alter-egos crowd the pop field, from the names of dub reggae producers to black metal singers and rappers. You can identify pretension in the way 1970s psychedelic funk reimagined the black experience through pulp science fiction rather than through the militant lens of Black Power. You can see it in prog-rock's charmingly overblown narrative follies—concept albums about the marriage problems of English monarchs (Rick Wakeman's *Six Wives of Henry VIII*) or fantastical creatures living underneath New York (*The Lamb Lies Down on Broadway* by Genesis). It is visible in punk's demonstrative nihilism and

post-punk's self-conscious intellectualism. Observe it at work in the dressing-up boxes of the New Romantics, the commodity fetishism of hip-hop, the futurist rhetoric of techno, in the shape-shifting personas of Bowie, Grace Jones, Madonna, and Lady Gaga, and the Grand Guignol shadow worlds of goth and black metal.

Pretension is at the heart of pop music, but there still exists a divide between those who demand their music be a serious art form and those who crave the exact opposite, or think pop should only deliver trashy pleasures. Rock's abiding obsession with bluesy authenticity, or the macho bravado found in rap, has always caused a tension between those who look to pop music for a representation of honest expression—three chords and a croaky voice that proves The Truth of your pain—and those who enjoy its artifice and caprice. Critics have for decades argued over whether pop is capable of comfortably accommodating so-called serious subjects or methods of production; for rock ideologues, any musicians "pretending to be something they're not" were morally suspect. The British comedy show *The Mighty Boosh* embodied this split neatly in its lead characters Vince Noir and Howard Moon: Vince is obsessed with any music that's glamorous, fashionable, and trashy, while Howard is the tortured, earnest jazz fan, longing for engagement with "serious" art and poetry.

Pop culture was built by amateurs and autodidacts. It's promiscuous history of influences consistently undermines assumptions about how so-called elitist art forms travel. Musicians framed as "authentic"—from working-class backgrounds or presumed, condescendingly, to be drawing

from deep wells of emotion unfettered by formal musical education—often pulled from surprisingly erudite sources. Iggy Pop, the wild frontman for The Stooges who grew up in a trailer park, cites the ONCE Festival in his hometown of Ann Arbor, Michigan, as a major influence. It was there he came into contact with music by avant-garde composers such as Robert Ashley, Pierre Boulez, John Cage, and Edgard Varèse. Varèse, the French pioneer of high modernist orchestral music, lived in New York, where jazz musician Charlie Parker would trail him around the streets, trying to find the guts to speak to him. The Beatles also assimilated ideas from European avant-garde music, along with lessons from John Lennon's partner, the Fluxus artist Yoko Ono, and Indian classical music. New York hip-hop pioneer Afrika Bambaataa, and techno producers in 1990s Detroit were profoundly influenced by the sounds of Kraftwerk, a group that began life at a music conservatoire in 1970s Düsseldorf. In the 1990s, the most feverish innovations in electronic music—entirely new forms such as rave, techno, jungle, house, drum'n'bass, trip-hop—were produced not by trained musicians but by self-taught artists wrangling with consumer audio technology in suburban bedrooms.

Kraftwerk sang about machines, railways, technology, and the new-dawn hopes of Europe after the war. They looked like young intellectuals on their way to attend a political think-tank in Brussels or a scientific conference in Geneva. From the 1960s onward—despite the anti-intellectuals who maintained that rock music had to come stained with the truth of tears and whiskey, or that pop not worry its pretty head about anything other than having fun—musicians have been

unembarrassed to reference feminism, literature, philoso-
phy, politics. There are countless examples to choose from.
Take, for instance, Joy Division's album *Closer,* inspired by
J. G. Ballard's novel *The Atrocity Exhibition* and featuring
on its cover a photograph by Bernard Pierre Wolff depict-
ing a neoclassical mausoleum in Genoa. Or Kate Bush; her
chart hit *Wuthering Heights* took Emily Brontë's novel of sex-
ual desire on the Yorkshire Moors as its subject, and her song
Cloudbusting was about a rainmaking cannon built by the
radical psychologist Wilhelm Reich. Bush was not producing
obscure music: in 1970s and '80s Britain, she was a huge star.
(*Wuthering Heights,* for instance, reached number one in five
different countries.) When in 2014 she announced her first
live concerts since 1979, tickets for the twenty-two shows
sold out within fifteen minutes. The popularity of her work
undermines the position that it's "pretentious" for musicians
to play with ideas beyond the dreary bounds of songs about
falling in love or feeling heartbroken, or that "people"—
whoever that conveniently nebulous mass are—don't have an
appetite for complexity.

Try describing a few of the most wildly successful pop
albums of the twentieth century without mentioning the art-
ist and title. A concept rock album about a fictional Edwardian
military band, featuring musical styles borrowed from Indian
classical music, vaudeville, and musique concrete, its sleeve
design including images of Karl Marx, Oscar Wilde, Marilyn
Monroe, Carl Gustav Jung, Sir Robert Peel, Marlene Dietrich,
and Aleister Crowley? That's *Sgt. Pepper's Lonely Hearts Club
Band* by The Beatles, one of the biggest selling records of all
time. How about a record exploring the perception of time,

mental illness, and alterity? Pink Floyd's *The Dark Side of the Moon*, which has to date sold around 45 million copies worldwide. Ask any of those 45 million who bought a copy of *The Dark Side of the Moon* if they thought themselves pretentious for listening to an album described by one of the band members as "an expression of political, philosophical, humanitarian empathy," and the answer would almost certainly be no. Queuing for the bag check at New York's Museum of Modern Art, I once overheard a young man complain bitterly to his girlfriend. "I hate modern art. I hate all that Picasso two eyes on the same side of a blue face shit." "What do you like then?" asked the girlfriend. "I like putting on my headphones, turning out the lights, and listening to Pink Floyd." Popularity ratifies cultural authenticity. The people have spoken and the convention—in the original sense of the word—has made its decision.

We could talk about why The Clash wrote music about the Spanish Civil War and Scritti Politti released a song about the philosopher Jacques Derrida, or how Laurie Anderson reached number 2 in the British charts in 1981 with *O Superman,* a song inspired by a Jules Massenet opera from 1885. We could analyze the impact of Marvin Gaye's *What's Goin' On,* a conceptual song-cycle about environmental destruction, social inequality, and war, told from the point of view of a Vietnam veteran. We might ask why Talking Heads had such success with songs about animal consciousness and the collapse of civic life under wartime conditions, or we could argue until we're blue in the face about why *Led Zeppelin IV,* heavy with opaque, quasi-occult symbolism and Tolkienesque allusions, became the third best-selling album

of all time in the US. Yet it's easy to over-egg the cerebral content of this music; its power also resides in emotional accessibility and a basic, visceral intensity.

Pop history is littered with pretentious follies, with ambitious projects overreaching themselves. In 1987, The Style Council—now there was a name—made a short film, scripted by Paulo "The Cappuccino Kid" Hewitt, entitled *JerUSAlem,* a road movie set in the English countryside and doubling as an oblique critique of British nationalism. A year later, the Pet Shop Boys—a band unafraid of writing a lyric such as "Che Guevara and Debussy to a disco beat"—produced their surreal musical feature film, *It Couldn't Happen Here,* a meditation on the desuetude of the British landscape. The film, directed by Jack Bond, takes the Pet Shop Boys on a journey from run-down seaside towns to greasy spoon cafes populated by time-traveling WWI fighter pilots and ventriloquist dummies holding forth on the philosophy of time. Both the Pet Shop Boys and The Style Council films were critical and commercial flops, but the willingness to risk creative overstretch that it represented was to be applauded. *It Couldn't Happen Here* was an avant-garde folly with a synth pop soundtrack. It featured actors including Barbara Windsor, famous in Britain as part of the *Carry On* comedy film ensemble, and Gareth Hunt, known for his role in the sitcom *Upstairs, Downstairs.* The result was a peculiarly wistful music video, its visual metaphors often over-egged but occasionally achieving moments of beauty. It was as if experimental filmmaker Derek Jarman had made a musical with poet John Betjeman, half longing for hazy childhood memories of afternoon teas and saucy seaside entertainments

and half damning them in the process too. Yet why can't a musician try to make a cinematic "state of the nation" poem told through dream imagery and pop music? They may fail miserably or they may fluke a masterpiece, but at least they tried to push their creativity. As Howard Devoto, of the bands Buzzcocks and Magazine, put it: "Pretentiousness is interesting. At least you're making an effort. Your ambition has to outstrip your ability at some point."

One need only look at Eno's friend Bowie to see pretentiousness in action. His was deliberate. "In my early stuff, I made it through on sheer pretension," he said in a 1976 interview with *Playboy.* "Show someone something where intellectual analysis or analytical thought has been applied and people will yawn. But something that's pretentious—that keeps you riveted." Bowie borrowed from mime, kabuki, the Beats, Andy Warhol, science fiction, high fashion, modern European art, and theater. He created personae and atmospheres that served as a refuge in fantasy for misfit teenagers, temporary flights of imagination from life in some godforsaken 1970s new town. "Don't fake it baby / Lay the real thing on me," sang Bowie, but that "real thing" could take you from the boondocks to the moon and back, by way of London, Tokyo, and Berlin. It was wildly popular music that—in songs such as "Life on Mars" and "Rebel Rebel"—paradoxically provided solace to loners, outsiders, those who didn't feel part of the crowd. Notes on the back of a Bowie sleeve could lead you to The Velvet Underground, its front cover to the German expressionists, and for those growing up in the high modern phase of pop—roughly from the late 1960s until the early '90s—a form of cultural literacy was nurtured through

references found on album artwork or in music videos. These were spaces that encouraged curiosity, gateways to art, literature, radical politics, and cinema.

Paul Morley once said: "There was a time when the only art I had on my walls was by Peter Saville." Band posters and record sleeves provided an art education everyone could afford. Saville's artwork for the Manchester post-punk label Factory Records, for example, drew directly from neoclassicism, Italian futurism, and the Bauhaus, and from books he found in the library while studying graphic design at Manchester Polytechnic. Indeed, even just the name of a favorite band—a group pretense that musicians and fans take deeply seriously—might provide a key to cultural history. Bauhaus was a German art and design movement in the early twentieth century, but it was also a Goth band from Northampton. *The Fall* was a novel by Albert Camus, which also gave its name to Mark E. Smith's group of working-class punks from Manchester whose music could take you from conversation in a Salford pub to a ballet about William of Orange made in collaboration with choreographer Michael Clark. An interest in American jazz—say, John Coltrane—could open a window onto Indian ragas and Eastern religion. Watch a pop video for The Smiths and you get to see work by Jarman. All those books, films, images, and sounds out there: pop told its audiences that they belonged to them too. Go and take them, learn from them. You do not need permission from a higher authority.

"The history of rock, in Britain at least, is a history of image as well as sound," wrote Simon Frith and Howard Horne in *Art into Pop*, "a history of cults and cultures defined by clothes

as well as songs." In British education, art and design institutions have historically functioned as incubators for pop culture. Following World War II, higher education colleges provided educational opportunities to students from a wide range of class backgrounds. Art schools in particular were places where young people, often from homes where the gallery and the concert hall were not part of the fabric of their lives, could be exposed to new ideas and lifestyles. Even an incomplete list of British rock and pop musicians with an art school education is long: John Mayall (The Bluesbreakers); John Lennon (The Beatles); Keith Richards, Ronnie Wood, and Charlie Watts (The Faces, The Rolling Stones); Jimmy Page (Led Zeppelin); Pete Townsend (The Who); Viv Stanshall (Bonzo Dog Doo-Dah Band); Brian Eno and Bryan Ferry (Roxy Music); Syd Barrett (Pink Floyd); Eric Clapton (Cream); Ray Davies (The Kinks); Freddie Mercury (Queen); Sade; Jarvis Cocker (Pulp); Graham Coxon (Blur); PJ Harvey; MIA; Florence Welch (Florence and the Machine). Of the British punk and post-punk generations alone, some forty-five musicians—including members of The Clash, Ian Dury and The Blockheads, The Raincoats, Wire, Madness, Adam and the Ants, The Slits, The Specials, Soft Cell, Cabaret Voltaire, The Sex Pistols, Scritti Politti, and Gang of Four— all attended art school. Going to art school might have been pretentious, but it allowed you to create new aesthetic and intellectual opportunities for yourself.

Pretentiousness and authenticity did the twist at art school. Frith and Horne describe how, in the 1940s and '50s, art students were jazz fans, attracted by its qualities of "seriousness" and modernity, and its refusal to be confused with

commercial pop music. Jazz symbolized cool individualism pitted against mass culture, and learning about it was an independent way to develop one's own intellectualism. When blues and rock'n'roll became popular in the 1960s, what art schools provided in terms of exposure to bohemian lifestyle choices was reflected by the rawness and perceived authenticity of these musical styles. "The Romantic ideology that floated round the art college cafeteria became part of the atmosphere of the blues clubs." Bands such as Cream and Led Zeppelin defined rock music as "serious, progressive, truthful, and individual," just like the 1960s art student.

With the influence of pop art in the late 1960s and into the '70s came an interest in surface and collage as a way to comment on culture. Educated at art schools in London, Newcastle-upon-Tyne, Reading, and Winchester, Roxy Music were the most famous embodiment of this shift to the postmodern, mingling, as Michael Bracewell has described, "science and artifice into a cabaret futura of decadent romance, playing with nostalgia as Bowie played with the future." Ferry (from a coal-mining family in Newcastle) and Eno (son of a Suffolk postman) fashioned Roxy Music's galaxy with nods to pop icons Humphrey Bogart and Eddie Cochran, to British pop artist Richard Hamilton and American experimental music. Artifice and authenticity worked in productive tension in the late 1970s with the first wave of punk, a movement that on the one hand encouraged vehement honesty and a do-it-yourself attitude, while proving deeply invested in questions of style and self-created identity.

This educational axis of art and pop—the one that provoked musicians to sing about French philosophers or

nineteenth-century novels, the nurturing of identity through music subcultures—is to some degree now ancient history, especially to those born in the 1990s and after. Pop music does not throw the same cultural weight it once did; its ideas and challenges are no longer central to social movements. In the UK and US, ruinously expensive tuition fees and cuts to art education have narrowed the range of class backgrounds that art students are coming from. But the magpie cultural education that pop music provided has left a strong legacy. "Libraries gave us power," as The Manic Street Preachers sang on "A Design for Life," and so too did records and films and television programs. Postmodernism, and all its liquid games of reference, was not just an idea incubated by the art gallery, the academy, or the architecture studio; it came from pop's intellectual permissiveness. The pretensions of individuals from all walks of life—their ambition, their curiosity, their desires to make the world around them a more interesting place—is cultural literacy in action.

THERE, AS USUAL, WAS EDELSON, DELIVERING
HIS POST-STRUCTURALIST ANALYSIS OF THE
MODERN NOVEL TO THE PRIVILEGED FEW.

The antipathy to style is always the antipathy to a given style.
—Susan Sontag, *On Style* (1966)

Pablo Picasso never got called an asshole, not like you.
—The Modern Lovers, "Pablo Picasso" (1976)

One sweltering afternoon in July 2013, rapper Jay Z shot a video for his song *Picasso Baby* at New York's Pace Gallery. The concept for the shoot was borrowed from artist Marina Abramović's marathon performance piece *The Artist Is Present*. For a total of 736 hours, Abramović sat in silence in the Museum of Modern Art's (MOMA) atrium as members of the public took turns to sit opposite her and gaze into her eyes, as if visiting a holy sage. It was pseudo-religious theater whipped up by media coverage, creating a hysteria that reduced some participants to tears and induced others to make impulsive proposals of marriage. For *Picasso Baby*, it was art world power players and celebrities who got an audience with Jay Z, watched behind cordons around the edges of the gallery by a handful of kids dressed to the nines, expensively moisturized young art collectors, and a smattering of critics. In his song, Jay Z name-dropped artists Jean-Michel Basquiat and Warhol. He mentioned Christie's auction house and showed off about "balling twin Bugattis outside the Art Basel" art fair in Switzerland. His song was a hymn to the

material worth of modern and contemporary art, only interesting when seen through the lens of class and race, of a successful black musician and businessman working the mostly white art world.

In March 2015, MOMA opened an exhibition of costumes, design, and videos charting the career of Icelandic musician Björk. It published a catalog explaining how the exhibition "aimed to broaden the canon of what contemporary museums exhibit and collect, while also raising questions about the longevity of pop music, a genre that is evolving and has not proven its classic timelessness." Klaus Biesenbach, the exhibition's curator, asked: "Can a work of popular culture achieve 'eternal truth and beauty' when it is independent and removed from its broader cultural context?" Pop music has produced some of the most serious cultural works of the past seventy years—a number of them older than canonical works of modernist art in MOMA's collection—but old hierarchies die hard, "eternal truth and beauty" reserved only for those with the correct identity papers.

What Björk's and Jay Z's art world appearances revealed were two forms of artistic status anxiety. For Björk, MOMA wanted to have its cake and eat it; to draw in the crowds but maintain a scholarly aloofness, a reserve, as if to say "you run along and have your fun while we talk about serious art with the grown-ups." At the *Picasso Baby* video shoot, Jay Z's superstardom played a dance with the art world's theater of understated but specialized aesthetic authority. Neither Jay Z nor Björk needed art world approval, and the argot of the museum can tell us little about their work that isn't already legible. But these musicians have been caught in the long and

torrid affair between pop music and modern and contemporary art.

Both art and pop music see in each other a space of relative open-mindedness and licensed bohemian excess—however much of a cliché that might be today—and both sanction models of free, expressive living. What pop music desires from art is its seriousness, the ways it gives the O.K. to intellectualism and confers gravitas on an art form that traditionally has neither official training academies nor scholarly institutions to support it. Art also knows how to handle exclusivity without having to talk money, how to function under the sign of connoisseurship and timeless aesthetic authority. Switching the other way, art lusts after music's legitimizing popularity, which lends it a different quality of authenticity to the intellectual ones art possesses. It hankers after music's power to mainline straight into the emotional bloodstream and its historical ability to generate a sense of sedition or danger, to galvanize large groups of people around it. Art loves the sociology around music and the complex codes that its subcultures generate through fashion, design, and performance. One of rock music's major foundational narratives came out of this affair: Warhol's relationship with The Velvet Underground. In Warhol's studio, The Factory, bohemian dissolution mixed with modernist innovation, and rock'n'roll primitivists consorted at the extreme end of the musical avant-garde. Here you could have sex, drugs, rock'n'roll, and intellectual kudos to boot.

Whereas the art museum that embraces pop music might just come off as a bit fusty, like watching a middle-aged uncle dance awkwardly at a wedding reception disco, the pop

musician aspiring to make "serious" art gets branded pretentious. Class rears its head once again, and the pretentiousness accusation disqualifies the musician from speaking in a certain register, or operating in certain ways. This is partly a malfunction of terminology. Visual artists are the only creative workers who use the word "art" in the title of their own profession—musicians, writers, actors, dancers, illustrators, cartoonists, architects, film directors, designers of all stripes: they're all artists too, but the appellation tends to get owned by visual artists. The title of "artist" carries with it a specific kind of baggage. To willfully take that on when you're something else—a musician, an actor, a fashion designer—suggests you have a high opinion of yourself, that you're worthy of being fêted by one of those large museums with neoclassical pillars outside, that what you are doing is not "mere" entertainment or work for hire.

These neuroses are played out in Michael Winterbottom's film *The Trip,* about two friends experiencing midlife crises. Comedians Steve Coogan and Rob Brydon play versions of themselves that leave the audience unsure quite how close to their true personalities they are. The Coogan of *The Trip* considers himself to be the serious artist. He is the tortured comic who also wants people to respect him for his acting range. Brydon winds Coogan up, because he is perfectly content with being an entertainer, happy to make someone smile with goofy mimicry, and doesn't need to be validated as an "artist." Do Coogan's ambitions make him pretentious when compared with Brydon's happy entertainer? Perhaps, but so what? Is Brydon more authentic because he can make the elderly lady running the William Wordsworth gift shop

smile with his impression of a small-man-trapped-in-a-box? No. What the two comedians symbolize in *The Trip* are anxieties about elitism and accessibility in the arts. *The Trip* is a film about what it means to take oneself seriously as an artist, to dare to step beyond the territorial borders of one's field and seek validation for that risk. At the same time, it is about valuing simple creative pleasures, recognizing the time and place for humor and lightness. Reciting Wordsworth by heart is impressive, but occasion sometimes demands a silly voice instead.

For many people, contemporary art epitomizes elitism and affectation much more than it does creative experimentation and freedom of thought. More than in any other field, art is where the nastiest brawls over pretentiousness are fought. It makes the blood vessels of otherwise cultured individuals burst in fury, and it aches at bone-deep class anxieties and intellectual resentments. It cues up every unexamined cliché about the artistic skills of five-year-olds and good places to find tailor-made Emperor's New Clothes. In the UK press, contemporary art is likely written up in the media as a scam designed to dupe a mythic Great British Public, all sharks in formaldehyde and piles of bricks, rather than honest, old-fashioned landscapes of the Highlands and portraits of notable public figures. It's rich pickings for newspaper cartoonists and editors. "It's all a con, right?" "Anyone could do this!" "Why is it art?" are the questions asked, not "What does it mean?" or "Why did the artist make it that way?" Contemporary art is guilty until proven innocent. Yet for all the antipathy toward it, in 2014, Tate Modern had 5.7 million visitors, while New York's MOMA enjoys an average annual

attendance of 3.5 million. That's a lot of people with an interest in the pretentious.

Art is a lightning rod for accusations of pretension, partly because it is dependent on dressing-up games: regardless of the work on display, art comes expertly ribbon-tied and gift-wrapped inside galleries—with their architecturally minimal atmospheres of what Michael Bracewell describes as "passionate neutrality"—and framed by professional language that can be alienating to experts and nonspecialists alike, a terminology that often seems more interested in casuistry than clarity.

Contemporary art causes rivers of bilious prose to spring in the media. In an article for *The Observer* newspaper published on November 26, 2000, the political broadcaster Andrew Marr described a couple visiting the Tate's annual Turner Prize for contemporary art: "They are in their twenties, probably lovers, certainly unmarried. He wears a thin gray jersey and leather trousers, with carefully maintained stubble and wrap-around shades, despite the dim light. She is Japanese, dressed in a bright plastic jacket, child colors, unsmiling." Marr writes about how they are part of "a modern tribe, a vast nomadic group, mostly young, urban, clever, a little intimidating, given to expensive hodden clothes and rimless glasses. . . . They seem poised. They treasure silence. I am talking, obviously, of the followers of contemporary art." He signed off his article with this thought: "That couple I started with—the cool ones? I hate them. It is time to elbow them aside and fill up the galleries with the rest of us." Musician Nick Currie—who goes under the name Momus—recognized himself in Marr's article. Writing on his website, Currie explained:

At first I'm merely amused to recognize myself and my "colourful, childlike" Japanese girlfriend in this caricature of the gallery-going public. But the more I think about it, the more disturbed I get that this sort of thing—an unashamed and blatantly expressed hatred of sophistication—is what passes in the UK for cultural coverage.

For Marr to say of two museum visitors he's never met, "I hate them," is cheap, them-versus-us populism, but it speaks to an ugly intolerance for difference, to an expectation that people must share the same aesthetic tastes and appearances and that if they don't they must be complicit members of an elitist racket hell-bent on excluding "ordinary" people from its world. Those "ordinary" people, it is assumed, could not possibly be interested in complex ideas and conversant in different forms of visual literacy.

When, in 2009, the Tate opened its "Altermodern" exhibition, organized by French curator Nicolas Bourriaud, the British press conflated anti-Gallic sentiment with the slur of pretension. Rachel Campbell-Johnston, writing in *The Times,* asked: "So what will this new Altermodern era entail? Don't expect the catalog to help you. Bourriaud is a Frenchman. He has svelte Gallic looks and a Left Bank aroma of Gauloises. And he seems to have been brought up on Baudrillard and Foucault in the way that the rest of us were brought up on our ABC." Charles Darwent described Bourriaud for *The Independent* as "co-founder of Paris's impenetrably *au courant* Palais de Tokyo." (Take the phrase out of the French. Does "impenetrably in-the-know" actually mean anything?)

The Evening Standard's Ben Lewis asserted that "the whole *mélange* is served up with the thick buttery sauce of French art theory, and the catalog essays will give anyone except a curatorial studies MA student a *crise de foie*." Waldemar Januszczak in *The Sunday Times* simply went with "degenerate," that old stand-by of moral arrogance and a word familiar to students of 1930s German art history.

We smell pretentiousness when we believe something is trying to stay out of reach from us. When we suspect someone is trying to put a red velvet rope and bouncer in our way. Because stories about Russian oligarchs and what they do with their money make better copy for media outlets than narratives about artists trying to eke a living, the art world is broadly perceived as a playground for the super-rich. The wider picture of its demographic makeup—the one that includes technicians, fabricators, scholars, social outreach and education workers, students, arts journalists, and museum guards, all struggling to make a living wage, all people Marr would describe as "the rest of us"—is occluded by the small percentage of the art world that makes money from it. Yet money is a topic that everyone can understand; it might be tacky to talk about it, but it's a convenient way into the conversation around art.

Artists themselves are hard to place socially. Intellectualism and creativity in the arts and humanities is a space of self-construction. Artists "have an unusual amount of say over the content of their own creative output," argues critic Ben Davis. "Personal fulfillment and professional ambition overlap—the classic middle-class aspiration." Archetypes of self-definition, artists are not necessarily materially wealthy, but appear to have freedom and move in high-class circles. They make things, but

often those things are unique objects that sell for high prices, or are unusual in form and content and require imagination and effort in order to understand them. It was Diana Trilling who said: "All artists are snobs, whatever the social group with which they make common cause, if only to the extent that they live by discriminations." Positioning of identity, in the art world, is a multidimensional game of chess in which the object is to play simultaneously above, below, central, and to one side of the action, and to learn when to accentuate one position more than another. In 1977, critic and art historian Lucy Lippard wrote "The Pink Glass Swan," a blistering essay attacking the class myopia of the art world. In one passage she describes how artists are "persistently working 'up' to be accepted, not only by other artists, but also by the hierarchy that exhibits, writes about, and buys her/his work. At the same time she/he is often ideologically working 'down' in an attempt to identify with the workers outside of the art context." Middle-class artists some-times display "a touch of adolescent rebellion against authority. Those few who have actually emerged from the working class sometimes use . . . their very lack of background privilege . . . as privilege in itself, while playing the same schizophrenic fore-ground role as their solidly middle-class colleagues." Play the art worker, or play the dandy aesthete; play the hard-partying celebrity artist, or play the pious theorist who prefers read-ing Theodor Adorno to boozy parties. Whatever the role, it's a complex act of pretension that can deny or enhance sta-tus where advantageous; like Jagger's accent slipping through twangs, burrs, and drawls.

Questions of class and access have deviled modernism since its emergence. *A Child of Six Could Do It!,* an exhibition

of cartoons about modern art staged by the Tate in 1973, included a drawing from 1877 depicting a policeman standing outside an exhibition of impressionist painting imploring a pregnant woman, "Lady, it would be unwise to enter!" John Carey, in *The Intellectuals and the Masses,* sees class conspiracies everywhere in early modernist literature. The lower classes, when not being compared to threatening hordes of animals, savages, or bacilli, were depicted in literature of the late nineteenth century and early twentieth as being "exclusively preoccupied with fact and mundane realism," unlike the aristocratic modernist intellectual or artist. Repeatedly, the figure of the lower-class individual trying to become cultured was belittled: Charlie Mears, the clerk with a wide-eyed desire for learning in Rudyard Kipling's *The Finest Story in the World;* Leonard Bast in E. M. Forster's *Howard's End* (who dies of a heart attack under a falling bookcase); or Doris Kilman, middle-class tutor to the Dalloway children in Woolf's *Mrs. Dalloway,* depicted by Woolf as "a monster of spite, envy and unfulfilled desire."

Perhaps because of snobberies like these, the suspicion that experimental forms of art must be a con job—the tool of an elite conspiracy to fleece the honest, hardworking taxpayer and maintain the economic interests of a cabal of intellectuals, dealers, and collectors—is a persistent one. The fable of the Emperor's New Clothes is brought up time and again, a conspiracy to dupe someone, a pretense designed to make the innocent or gullible look stupid. It's a narcissistic paranoia; most artists don't have the time or money to bother playing such a prank and are far more concerned with spending their

days pursuing ideas in the studio, however absurd those ideas may appear to others.

Accusations of elitism circle above the art world in a perpetual holding pattern. Here the word "elite" never means "highly trained" or "of exceptional ability." Instead it gets used as a synonym for "intellectual," "urban," "rich"—wielded in much the same way the word "pretentious" is. The art world incubates many subcultures. Some are in it for shits and giggles, others because it is a vocation, a life they'll never make money from but which sustains them in deep creative ways. Some enter for scholarly reasons, others to do business or because they enjoy playing its politics. Within it there is as much collegiality and internecine bickering as within any other subculture, and the assumption that it can be grouped together as one homogenous group is shaky at best. The apparent difficulty of contemporary art suggests that it requires a specialist education in order to be understood, that it demands time for study that only the privileged can afford to spend. Therefore, it's art made for cliques, not crowds. Artworks can certainly be opaque; I've been an art critic since 1999 and still find many artworks hard to fathom. But for me therein also lies the fun: the pleasure of figuring out a puzzle, or piecing together a backstory, or simply applying your imagination to your own reading of whatever painting or sculpture you're looking at. There is no "wrong" way to look at art, only schools of thought—some of which the artist might support— that suggest a particular way of looking, or arise from a feeling of duty to be true to what artists say their work is about.

Artist Mark Leckey's performance *BigBoxStatueAction,* first staged at Tate Britain in 2003, provides a useful way of

looking at these issues. Leckey built a speaker sound system to the same dimensions as a work in the Tate collection; Sir Jacob Epstein's sculpture *Jacob and the Angel,* completed in 1941. Epstein's sculpture—sturdy and muscular, carved from an almost luminous block of alabaster—depicts the Biblical story of Jacob, who wrestles all night with an anonymous man who, at daybreak, reveals himself to be a messenger from God. Leckey placed his sound system opposite the Epstein sculpture and played music at it. Tracks ranged from the beautiful Beach Boys song "Our Prayer" to the menacing electronics of Throbbing Gristle's "Persuasion." The setup had echoes of Steven Spielberg's film *Close Encounters of the Third Kind,* in which scientists attempt to communicate with a vast spacecraft using musical tones. "There's an object—in this case, a sculpture—that I want to experience as fully as I possibly can," explains Leckey.

> All sorts of noise stops me from doing that: art history, the museum, class. I didn't understand the Epstein sculpture. I found it a very baffling, confusing piece of work: like Modernism is an ancient language I can't connect with. I couldn't relate to the reasons why this sculpture was made . . . I saw *BigBoxStatueAction* as just a different form of art appreciation. It was like another way of reviewing a piece of work. At the end of the performance I understood the Epstein far better than when I went in.

Jacob and the Angel was vilified in its day. In 1942 it was shown at Blackpool's Louis Tussaud's Waxworks, a seaside

freak show entertainment. It wasn't the only Epstein work to rouse public anger. *Rima*, made for London's Hyde Park in 1924, was daubed with green paint in 1927, then tarred and feathered in 1929. *Day and Night*, commissioned in 1927 for the headquarters of the Underground Electric Railways Company of London, caused a public outcry for alleged indecency. Today, Epstein's works are considered classics of modernism. We might think here once again of Quentin Crisp's line that "Those who once inhabited the suburbs of human contempt find that without changing their address they eventually live in the metropolis." What Leckey did in his performance was to pay homage to Epstein using the modernist vernaculars of pop music, to speak to the sculpture in a language he grew up with and immersed himself in. *BigBoxStatueAction* suggested that there are many different ways of responding to art. They don't have to be stuffy, academic. They can be personal, intuitive. It suggested that over time the ways we see and think about culture change. Attitudes about the acceptability and legitimacy of an art form eventually dissolve into one another, reconstituting themselves over time into new preferences and prejudices.

Circle back, for a moment, to the figures of the amateur and the professional. All but the most cynical artists are amateurs—amateurs in the original French sense of the word, a "lover of" what they do. Professional artists are those who operate inside established networks and systems geared toward supporting their work—a professional community with a shared language. The meaning of the art they make can be hard to parse, yet millions of people make things just as strange and difficult. Jeremy Deller and Alan Kane's

ongoing *Folk Archive* project documents objects, artifacts, and events made by communities across the UK. Carved vegetables, tar-barrel rolling gloves, topiary, straw bears, sound system stacks, political banners and murals, spoof plaques and satirical parking tickets, horn dances, elaborately customized bikes and decorated crash helmets, "hare pie scramble and bottle kicking" competitions. These are things people make and do: for themselves, for each other, or because tradition demands it. The meaning of these objects and rituals may be lost on me and you, but they hold significance for those that produce them. These artworks may not get written about in art magazines or be sold for astronomical figures, but they are testament to the same creative impulses—the same desire to make the world more interesting—as works by professional artists.

The idea that modern art is pretentious is clearly tied up with traditional ways of assessing artistic labor. A book physically embodies the amount of effort that went into its production: numbers of pages, of words. A film, although the millions spent on producing it might seem excessive, has credits at the end that clearly demonstrate what a big team of artists and technicians are necessary to produce it. We value actors for their skill at portraying a character naturalistically, with emotional intensity or with perfect comic timing, for being able to remember lines or pull off dangerous stunts. (And even if they're useless at acting, we can enjoy watching them because they're easy on the eyes, or they allow us to be swept along by a good story.) A visually slight-looking piece of minimal or conceptual art—Martin Creed's lights going on and off in a gallery, or Carl Andre's stack of

firebricks—doesn't clearly wear the intellectual labor that might have gone into it or that might be produced by it. A gap between visible effort and the authoritative aura of a museum or gallery might lead a visitor to feel unconvinced of the artistic worth of the piece.

Then there's the question of technical skill. One type of musician, for instance, could be a virtuoso playing beautiful music, and it would be easy to see why they'd be celebrated for it. Another might play in a clichéd idiom, but even if you find their music middle-of-the-road, it's still clear that they're proficient at their craft. There are musicians who may not be technically gifted, and their playing might be rough around the edges, but their music might deliver an emotional force that makes technique an irrelevancy. Literature, cinema, and theater have all had their turn experimenting with form but to this day largely do what they've always done, which is tell stories. The gap between what we expect a book to do and what it does is small, unlike in contemporary art. We get our principle idea of what art should be from school, where we're taught to paint and draw what's in front of us, to make that picture look as "lifelike"—you could say, "authentic"—as possible. This educational model is rarely challenged and so we feel disappointment when art at a professional level doesn't affirm those expectations.

Comfort with an art form that uses language comes because we all own it, to one degree or another. Words come from flesh and bone and only require a body to read, write, speak, or listen to them. But language also intimidates people into respect: it is the tool of untrustworthy politicians, of bureaucrats—of those trained in the arts of rhetoric. It can

be used to control and crush others; fluency and confidence in language is a symbol of education and power. Perhaps it's because of this deep-seated respect and fear of language that the media will vent spleen over large sums of money being awarded to visual artists for making images and objects, but never criticize a literary prize for giving thousands to a writer for sitting behind a desk and making up a story.

With the arrival of photography in the mid-nineteenth century, art's mimetic role—what it could record and tell us about the world—was thrown into doubt. In reaction, painters and sculptors forged new and highly subjective languages with which to express emotional states, to reflect the rapid changes that modernity was bringing on the world. Some artists turned to purely formal explorations of shape and color that had no direct correlation with external reality. Others looked deep into their minds for inspiration in dreams, the subconscious, or their emotions. There were artists who took new forms from mass media and collaged them directly into their work. In the 1910s Marcel Duchamp questioned the very worth of making objects and images in the first place, arguing that if he said an object was a work of art, then it was a work of art. (His *Fountain,* a standard urinal turned on its side and signed "R. Mutt," has been used as Exhibit A in the case against modern art ever since it was first shown in 1917.) Since the heady early twentieth-century phase of modernism, artists have been hunting restlessly for new ways to represent the complexity of experience and debating whether craft or intellectual smarts were more important. Some thought that the more technically virtuosic you were, the better. For others, the more you were able

to channel an inner voice unfettered by the trappings of your art education, the more authentic an artist you must be: the more paint you slathered on the canvas, the more emotions you must be feeling. By the 1970s, and following the developments of Fluxus, pop, minimal, and conceptual art, what could be achieved intellectually became valued as much as what could be made with the hand.

Art never returned to a prelapsarian era, a time when art imitated nature, longed for by those who have thought its more radical ideas to be pretentious. Instead it committed itself in spirit to innovating new ways of seeing the world. At times, art has appeared encumbered by its own revolutionary baggage: over a century later those avant-garde stories of restless innovation have proved hard to kill, setting up expectations that artists must always be making art new each day. Much of the time what is touted as being good in contemporary art is simply what's familiar, what fits an established pattern, whether one of shouty radicalism or quiet classicism. Because the institutions of art are, like everything else in life, run by people who are variously talented, flawed, and born without psychic powers of foresight, assertions are made about art that time proves wrong. (The advertising pages of old art magazines are a great place for discovering which artists have enjoyed lasting careers, and which had work once sold as champagne that cannot even be passed off as tap water today.)

Claims made on behalf of artists that they are "challenging," "undermining," or "interrogating" the status quo (a curiously crypto-military language), or "breaking down boundaries" create false expectations. They occlude the fact

that artists simply get on with making whatever they want to make and do not set out each day to set the old world ablaze. Many artists are big fans of the old world and would be sad to see it razed to the ground.

One reason art is labeled pretentious is because it embraces creative risk, and risk often entails failure. Failure is one mechanism by which the arts move forward—just as it is in science. Not every artist can make a masterpiece, yet it's the experiments that quietly stumble forward that lead to them. There's an altogether more generous view of pretentiousness that understands the gap between expectation and actuality as a productive necessity rather than a flaw. As Woody Allen put it, "If you're not failing every now and again, it's a sign you're not doing anything very innovative." To understand the artistic process is to accept that pretentiousness is part of the creative condition, not an affliction.

Pretension is about overreaching what you're capable of, taking the risk that you might fall flat on your face. Without people stretching themselves and—self-consciously or otherwise—risking failure, most of the major works of art, music, literature, cinema, dance, philosophy, science, clothing, design, architecture, engineering, horticulture, and cuisine that we cherish would simply not exist. New discoveries would not be made, or—like many great innovations—accidentally stumbled across. It is the engine oil of culture; every creative motor needs it in order to keep running and not seize up and corrode with complacency.

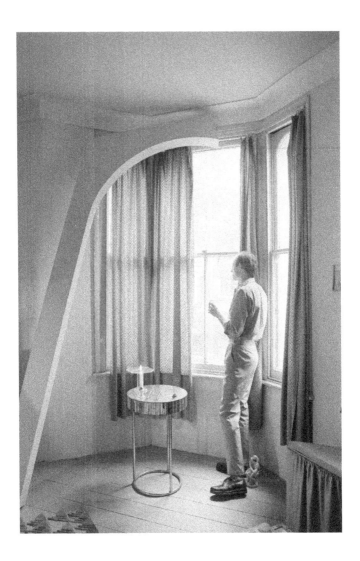

For at our essence, at our core, we are not professionals. We are amateurs. We are myth, history, and advertising, but, still, we exist; we are real, and we are simply beginners. It's how we thrive. We begin and therefore perpetually remain connected to the spark. We ask questions, we thirst, and we learn. And the dissenters complete us, causing us to be better.

—Richard Maxwell, *Theater for Beginners* (2015)

Being human offers *homo sapiens* variety, or some elasticity, in social life, though sociologists claim that people's personalities disappear with no one around. Imagining this evacuation, I see a person alone in a self-chosen shelter, motionless on a chair, like a houseplant with prehensile thumbs.

—Lynne Tillman, *Blame It on Andy* (2011)

And yet pretentiousness is always someone else's crime. It's never a felony in the first person. You might cop to the odd personality flaw; the occasional pirouette of self-deprecation is nothing if not good manners. Most likely one of those imperfections nobody minds owning up to, looks charming in the right circumstances. Being absentminded. A bad dancer. Partial to a large gin after work on Fridays. But being pretentious? That's premier-league obnoxious, the teammate of arrogance, condescension, careerism, and pomposity. Pretension brunches with fraudulence and snobbery, and shops for baubles with the pseudo and the vacuous.

Undoubtedly you're the sort to take an interest in the world around you. Think about what gets you out of the house on weekends. Is it dirt-biking or brewing craft ales? Maybe bird-spotting, kickboxing, visiting medieval churches, or attending cosplay conventions dressed as Harry Potter. Perhaps it's art appreciation, bread baking, five-a-side soccer, astronomy, philately, writing erotic fan-fiction, playing soldiers from the comfort of your couch in *Call of Duty,* metal-detecting, LARP-ing, running, playing darts, keeping goldfish, reading up on Middle East politics, cabinetry, restoring old hi-fi equipment, learning Russian, amateur dramatics, pickling vegetables, cultivating cacti, knitting, learning the clarinet, free climbing, stand-up comedy, philosophy evening classes, caravanning, consulting the tarot, fly-fishing, yoga, DJ-ing, making ceramic Toby jugs, designing your own clothes, photographing vintage American diners for your Instagram feed, following college athletics, floristry, collecting true-crime books, racing 1970s muscle cars, or watching old silent films. Whatever it is you do, I'll bet you'd never think it pretentious. That's because you do it, and pretension never self-identifies. Pretentiousness happens over there. In the way *he* writes. In *her* music taste. In the way *they* dress. And who hasn't before described a person, place, or thing as pretentious? Right-thinking folk curl up and die if accused of it. Always pejorative, the word "pretentious" is easy shorthand for dismissing novels, plays, and movies. It's used to slag off music, bitch about what a person is wearing, or rubbish the décor in a hotel. Scan the culture page in a major newspaper and likely as not you'll find the word lurking in a film write-up or op-ed piece supporting

cuts to arts funding. It is ammunition for apoplectic one-star Yelp.com restaurant reviews and is a character trait strenuously denied in online dating profiles. You can smell it in the air when complaints are made about something being too "arty," and hear the suck of inevitability as it gloms onto the word "elitist."

Actor Hugh Grant tells listeners of BBC Radio 4's *Film Programme* in 2012 why the films of Jean-Luc Godard are "pretentious nonsense." Marisa Gerber, reporting on the proper way to pronounce the names of Hispanic neighborhoods in Los Angeles, discovers that "no one can seem to agree if using the Spanish pronunciation is respectful—or pretentious" (*LA Times*, May 7, 2013). Theo Hobson declares atheism to be "an ideology that's pretentious and muddled" (*The Guardian*, June 6, 2007). Italian politician Maurizio Gasparri causes outrage as he tweets that the English are "pretentious pricks" when Italy beat England during the 2014 World Cup. Pulitzer Prize–winning novelist Anthony Doerr tells Michelle Dean that he "grew up where to call yourself a writer would be pretentious" (*The Guardian*, April 22, 2015). Following the 2015 National Basketball Association finals, David Blatt, coach of the Cleveland Cavaliers, tells the press: "I always knew I would coach in the NBA, but it would have been slightly pretentious of me to say I believed I would be coaching LeBron James in my first season and that we'd reach the finals" (*The Jerusalem Post*, June 16, 2015). FourSquare offers a guide to "The 15 Most Pretentious Places in Washington." On November 2, 2015, *The Daily Beast* posts an article wondering why so many people "are quick to stereotype jazz as the music of the pompous and

pretentious." According to Jean Cole, editor of Minnesota's HometownFocus.us website, the favorite dishes of presidents Theodore Roosevelt, Franklin Delano Roosevelt, and John F. Kennedy were "simple, non-pretentious and good." (Teddy Roosevelt liked corned beef hash, FDR enjoyed kedgeree, and JFK was a fan of New England fish chowder.) Journalist Ruth Dudley Edwards informs her readers that her "prevailing thoughts about the writer Salman Rushdie" are that he is "self-important, pretentious, attention-seeking, and ungrateful" (*Daily Mail*, June 19, 2007). Rand Richards Cooper, writing a review of the Mexican restaurant Sayulita for *The New York Times* on June 7, 2015, describes the food as "spiffed up south-of-the-border fare that is smartly presented but never pretentious." Anthony Peregrine, in *The Telegraph* on January 28, 2015, gives "Tips for the French: Learn How to Drive and Be Less Pretentious." Writing for *Forbes,* tech journalist Jon Markman observes that "every smartwatch put on sale so far looks either nerdy, pretentious, or ridiculous." On BBC 5 Live in 2009, Richard Bacon gets to grips with a question that has vexed humanity since the dawn of viticulture 7,000 years ago: "Is wine overrated and pretentious?"

The pretentious flaws of others affirm your own intellectual or aesthetic expertise. Simultaneously, their fakery highlights the contours of your down-to-earth character and virtuous ordinariness. It is your plain speaking that makes you trustworthy. That person's pretentious use of words hides the fact that they do not have anything of substance to say. Like the unnamed narrator of Thomas Bernhard's novel *Woodcutters,* watching guests arrive at a dinner party and savaging each of them for their artistic and personal failings,

only you see the truth of the world—everyone else is putting it on. "As soon as they entered the apartment they more or less fell into my trap, behaving as though they were unobserved, whilst in fact I was observing them intently from my wing chair . . . What ridiculous, vicious people they are!"

It is axiomatic that pretentiousness makes no one look good. But pretension is measured using prejudiced metrics. The baselines against which authenticity and pretentiousness are calibrated vary wildly. Anti-pretension critics conscript words such as "logic," "reason," and "the facts," to make their assessments look objective. The accuser of pretension—naturally thinking themselves to be the real deal, in possession of an educated and discerning mind—believes that somewhere else in the world is a genuine article that the pretentious thing or person aspires to be, but is falling short of or exaggerating it.

This accuser rarely itemizes both what is being aspired to and just why it is that the subject in question fails to make the grade. When a person decides that a restaurant is pretentious, the "authentic" restaurant to which it's being compared and the values that provide The One True Restaurant with its bona fides are seldom revealed. If a book on pretentiousness is deemed pretentious, no example of a salt-of-the-earth study of the topic will be given. There is no need. Pretension just *is.* The tendency is to understand it only as the cousin of affectation, one of the dark arts of charlatanry. To be pretentious is to be deceitful, untrustworthy. As philosopher Harry G. Frankfurt says in his book *On Bullshit*, "What is wrong with a counterfeit is not what it is like, but how it was made."

Pretension is the name of the tastefully minimalist, white-painted gallery in which we duke it out over questions of class and judgment. It sets the amateur against the professional in a game rigged by tradition, qualifications, and institutional approval. Puncture the word "pretentious" and out scuttles a bestiary of class anxieties: fears about getting above your station, and the urge to police those suspected of trying to migrate from their social background. The word is bent to fit emotional attitudes toward economic and social inequality and used as shorthand in arguments over authenticity, elitism, and populism. In the arts, pretentiousness is the brand of witchcraft used by scheming cultural mandarins to keep the great unwashed at bay. It's a way of saying that contemporary art is a "con" and that subtitled films are "difficult"—that they do not appeal to everyone and therefore must be aimed at the sorts of people who think they are better than everyone else, the sorts of people who like French or Chinese or Mexican films because they won't stand up for their country's alleged clear-eyed pragmatism over another's pseudo-artistry. The intellectually insecure drop the word "pretentious" to shut down a conversation they don't understand, when simply saying "I don't know" or asking "Can you explain this?" would be more gracious ways to admit to being in the dark. Cutting someone down for pretension reveals, ironically, embarrassed arrogance rather than humility. The insult "pretentious" is deployed as an insidious euphemism of distaste for sexual difference, a synonym for "effeminacy" or "dandyism." Apply it to the topics of gender, sexuality, and race, and the accusation of pretension swiftly becomes a measure of how antediluvian the accuser's attitudes are.

Being pretentious is rarely harmful to anyone. Accusing others of it is. You can use the word "pretentious" as a weapon with which to bludgeon other people's creative efforts, but in shutting them down the accusation will shatter in your hand and out will bleed your own insecurities, prejudices, and unquestioned assumptions. And that is why pretentiousness matters. It is a false note of objective judgment, and when it rings, we can hear what society values in culture, hear how we perceive our individual selves. Pretentiousness matters because of what it teaches us about the creative process. Try it: try holding pretension up to the light. Turn it and observe where the light and shade falls.

So you thought the film you just saw was pretentious, and so was the date you took with you. You thought the food and service at the restaurant where you had a bite to eat after was also pretentious. But pretending to be . . . what, precisely? Perhaps the film was badly made—many are—but dealt with ambitious ideas that few others have tried to get to grips with in cinema. Maybe the arrangement of food on your plate in the restaurant was too fussy but it tasted good. If your date's outfit embarrassed you, could that have more to do with your anxieties about what other people think of you than their self-image? The accuser of pretension always presumes bad intentions. Truth is, more often than not pretension is simply someone trying to make the world more interesting, responding to it the way they think is appropriate. It's more likely that what you think is one person's pretension is another's good faith.

It's possible you thought the film was pretentious because it was in "arty" black and white, in a language other than

your own, and you don't consider yourself the kind of person that goes to see foreign movies, because only pretentious people do that. What are those pretentious people trying to be? Swedish? French? Brazilian? American? Indeed, what if they are Swedish, French, Brazilian, or American? What's so bad about taking an interest in how other people on earth see life? More important, what if you gave yourself a break and, just once in a while, became the kind of person who goes to see arty movies made in other parts of the world? What might happen if you allowed for the idea that going to see both the arty black-and-white film and the action hero explosion-fest is a perfectly o.k. thing to do, that both experiences are valuable? To fear being accused of pretension is to police oneself out of curiosity about the world.

Pretension is understood to be flimsy. It's a cardboard theater set, likely to be swept away by the slightest breeze. We make that association because, as Andy Warhol observed, "in some circles where very heavy people think they have very heavy brains, words like 'charming' and 'clever' and 'pretty' are all put-downs: all the lighter things in life, which are the most important things, are put-downs." What we are reluctant to admit is that culture would have no color without pretension. It would be a lifeless shade of Gap-store beige. The doors to imagination would be kept locked tight in fear of finding behind them something that violates the consensus over what is an acceptable creative act, what is an acceptable bar to drink at, what is an acceptable pair of shoes to wear to work.

If each poet, musician, dancer, florist, and pastry chef the world over had been told, early in their lives, that it was

pretentious for them to take an interest in literature, music, theater, gardening, or cooking—that they could only be true to the circumstances into which they'd been born—then millions of imaginations and minds would have been stunted, millions of hands would never have learned to do anything new. If each school pupil with an interest in design had been told to forget about taking art classes because they were useless or pretentious, to put away silly ideas above their station of going to art college and to go and get a proper job instead, then they would never have taken an art foundation course, gone on to study graphic design, then trained as an information, product, or industrial designer who makes road signs, kitchen appliances, or medical instruments. Nobody would have taken their fine art degree into the world of social care and used it to teach art therapy to people with learning disabilities. Certainly there would be nobody to tell your great aunt Ethel what that big Tintoretto in the National Gallery means. Nobody would have joined a local amateur dramatic club and built on their love of acting in order to go and make the sitcoms you love to watch, and nobody who held on to their fascination with animated films would now make the cartoons that enchant your kids on a wet Saturday afternoon. There would be nobody to reflect the world back at you. As Jonathan Richman put it in his song "Door to Bohemia": "My parents didn't stand in my way when I was sixteen years old / They knew I had to find, they knew I was pining, for the door to the art world / They knew that I had to find the door to Bohemia / I had my pretentious artwork, but my parents didn't laugh too bad / I needed to be reined in once in a while / But they didn't have a hateful vibe, they didn't demean."

Pretension can be found in all walks of life, and it's not just wars of values and tastes that are waged with it. It conditions the arts, undoubtedly, but also politics, religion, and sport. (Anyone who has enjoyed listening to veteran soccer commentator Ray Hudson can attest to the imaginative flair of pretentious sports reporting. "It's a Bernini sculpture of a goal, that rivals the *Ecstasy of St. Teresa*, a magisterial hit by an artist!" was how Hudson described Ronaldinho's match-winning goal for FC Barcelona in 2007.) Pretension gets sticky with a mess of unpleasant traits: narcissism, lying, ostentation, presumption, snobbery, selfish individualism. These are not synonyms for each other. The pretentious are also those who brave being different, whether that's making a stand against creative consensus or running the gauntlet of catching the last bus home on a Saturday night dressed differently to everyone else.

It can never be appropriated as an entirely positive word, but pretentiousness matters because of what it reveals about how your identity relates to mine, theirs, and everyone else's. And hard though it may be to accept, being pretentious is a part of what we do every day. Pretentiousness keeps life interesting. Without the permissions it gives—the license to try new experiences, to experiment with ideas, to see if you want to live your life another way—people from all kinds of backgrounds will not be exposed to difference, to new ideas or the histories of their chosen field. A rich culture sustained by people who devote their lives to it, often with little reward or recognition, is a pretentious one.

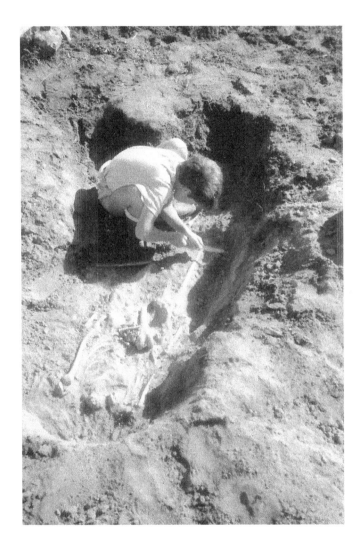

June 4th, 1989: Primrose Hill, Staten Island, Chalk Farm, Massif Central, Gospel Oak, São Paolo, Boston Manor, Costa Rica, Arnos Grove, San Clemente, Tufnell Park, Gracetown, York Way, Videoton, Clerkenwell, Portobello, Maida Vale, Old Ford, Valencia, Kennington, Galveston, Holland Park, Studamer, Dollis Hill, Fougères, London Fields, Bratislava, Haggerston, Lavinia, Canonbury, Alice Springs, Tooting Graveney, Baffin Island, Pollard's Hill, Winnipeg, Plumstead Common, Hyderabad, Silvertown, Buffalo.

—Saint Etienne, "Girl VII" (1991)

POSTSCRIPT

June 4th, 1989. It's as good as any place to start. I had turned thirteen in April of that year and was living with my parents in their modest white, semidetached house on the main road out of Wheatley, a village ten miles east of Oxford. Hunkered in a small valley, Wheatley has existed since the Roman occupation of the British Isles, and until the arrival of the car and construction of the A40 motorway, was a staging post on the main road from Oxford to London. Pretty seventeenth-century cottages and pubs sit next to Victorian churches, interwar social housing and new-build homes for

London's expanding commuter belt. It's called a village, but for a long time it's been the size of a small market town with its own state primary and secondary schools, an industrial park, a supermarket.

June 4th, 1989. On the opposite side of the street from my parents' home is a group of houses built in the 1920s by the Wheatley Urban District Council. Growing up, I looked at them every day. Designed in the "Tudorbethan" style, they have brown pebble-dash walls and large black-and-white timbering on the front. Each has a garden big enough for growing fruit and vegetables, and the houses are grouped into semidetached pairs, gently angled so that they face toward each other. Trees and hedgerows surround them. Firemen, school teachers, care workers, juvenile delinquents, cooks, retirees—custodians of the village's oral history who have lived in Wheatley their entire lives—call them home. For Andy and Christine Andrews, who used to live in the house directly opposite my parents' and who babysat me as a child, this was the first and only brick house they ever lived in, after years living in a caravan on the edge of the village. Back in 1938, John Betjeman had described these buildings as among the ugliest houses in Britain. Perhaps he loathed them because they aspired to a history they didn't have, or were symbols of undeserved class mobility. "Private, timber-faced, and gabled villas had been familiar in wealthier Henley and Oxford," observed my dad, "but now ordinary people had them and on prime sites, not today's marginal wasteland." Why did the Tudorbethan pretensions of social housing matter? After all, they were about as authentically Tudor or Elizabethan as any neoclassical or

neo-Gothic stately home in Britain was authentically classical or Gothic.

June 4th, 1989. Maybe. I can't recall the month but 1989 sounds about right. I had borrowed from a school friend a cassette copy of *The Velvet Underground & Nico*. It didn't make me particularly original—it's on the beginners's curriculum for any budding rock music fan these days—but it made my imagination rapidly telescope from Wheatley to Manhattan. A kid's idea of New York kindled by *Superman* and *Ghostbusters* entered puberty, and I got the hots for CBGBs and Warhol's studio, The Factory. Not that I understood what those things represented—why, for instance, the album cover had the name "Andy Warhol" written on it in large letters rather than the band name. Then my older brother Mark showed me books of Warhol's art and photographs of *demimonde* life at The Factory. Mark had left home a few years previously to train as a nurse in North Wales, but by the end of the 1980s, he changed tack to retrain as an interior designer. In his nursing days he worked at a hospital in Bodelwyddan, on the outskirts of Rhyl, not too far from where my Mum's side of the family is from, in rural Snowdonia. Rhyl, a small seaside town, was hardly New York or Paris, but Mark had always possessed an acute understanding of how music and fashion could take you to other places, other periods. His tactics had always been chameleon, and his 1980s moved from Two-Tone suits through 1940s demob gear to New Romantic, then— via Style Council soul boy—to Smiths-inspired shades and paisley shirts. Mark was into John Waters films, American B-movies, and Evelyn Waugh novels. For his eighteenth birthday he rented the local Boy Scouts meeting room and threw

a 1940s fancy dress party, playing music off old gramophone 78s. But to walk through Wheatley dressed up was to run a gauntlet of suspicion; to be authentically himself, interested in unusual art and fashion in a small town, was an act of physical bravery.

Since the age of sixteen Mark had collected *The World of Interiors* magazine and had used money saved from a Saturday job at a local jeweler's shop to hone his eye for small antiques and prints. His bedroom décor was not that of your average teenager: a watercolor by one of the Scottish Faed brothers hung next to a silver mirror printed with a picture of Siouxsie Sioux. Decades before eBay and Etsy, Mark had an eye for a bargain, for being able to find vintage treasures where nobody else was looking. I have a memory of visiting Mark's nursing digs in mid-1980s Wales during school holidays and being met at the door of his room by a marble bust of Voltaire—accessorized with blue-tinted Victorian sunglasses—and the record *Architecture and Morality* by Orchestral Manoeuvres in the Dark playing in the background.

My eldest brother, Karl, had left home when I was very young. He found no stimulation in school, and it alienated him. The Air Cadets in his spare time did much more for him. Like Mark, Karl was an autodidact, but he had different fields of interest. At sixteen, he worked at a local car garage, and then at age seventeen, Karl joined the Royal Navy for four years. After he'd finished his naval stint, he had every traditional and modern sea skill, and a seafarer's confidence. By that time he had taken a correspondence course in basic aerodynamics and learned how to navigate a boat by the stars. My parents

understood he needed to get out of town. They persuaded Karl to save up money and go and see the world. He used his savings to get down to the south of France where he found work as a deckhand on boats in the Mediterranean. Soon he was crewing yachts for film stars and Middle Eastern royals. He eventually became a professional yachtsman—racing and couriering boats across the oceans—and for years Karl lived a life of adventure out of two bags: one held a few T-shirts, a spare pair of jeans, the other a couple of cassette tapes and books. An occasional postcard from the Azores, a phone call from New Zealand, or a glimpse of him on the ITN television evening news winched up a boat mast in a South Atlantic squall during the 1985 Whitbread Round the World Yacht Race were tantalizing signposts to other possible lives. Karl was rarely home during my childhood but the idea of him was colossal.

June 4th, 1989: That year, with the exception of family holidays to Wales, the ten miles that separated Wheatley from Oxford was the farthest I got from home. For some reason, in the pictures Mark had shown me of Warhol & Co., it was the striped T-shirts they all seemed to wear that caught my eye. On Saturday afternoon excursions to nearby Oxford, I'd see twenty-somethings wearing similar striped tees with black jeans, winklepickers, and shades. The look was the VU by way of Thatcher's UK, filtered through bands such as The Jesus & Mary Chain, The House of Love, Spacemen 3, and Felt. They were just ordinary students, but from the top deck of the number 280 bus, they looked like a part of 1960s New York teleported to 1980s Oxford.

That same year I detected other faint signals in town, although I did not know enough to fully parse their meaning.

Like New York's Harlem, Oxford had an Apollo Theater. (Mark had seen Kraftwerk play here on their *Computer World* tour.) Next door to this on George Street was a grotty nightclub called Downtown Manhattan. On Queen Street was a branch of a women's clothing shop called Chelsea Girl. Local shoegaze heroes Ride had a song called "Chelsea Girl" too. Chelsea Girl was somewhere your mate's older sister shopped. "Chelsea Girl" was Ride's engine roar of over-driven guitars in a song about driving up to London. When I later became a student, I learned that Chelsea girls were from West London, uniformly wealthy, blond, and all named Caroline. But I knew that Chelsea girls were also named Nico, Brigid Berlin, Edie Sedgwick, International Velvet, and Ingrid Superstar and hung out with Andy in a seedy hotel in downtown New York City.

Artist and graphic designer Peter Saville once described how, living in Manchester in the late 1970s and '80s, the atmospheres evoked by the European modernist aesthetics he used for his Factory Records designs seemed both a world apart from the grim, post-industrial realities of Northwest England, and also strangely similar. If you were romantic enough and half-closed your eyes, run-down 1970s Manchester could have been 1970s Berlin—the kind of city where existential crises could be had, where daily life was experienced on a battle-field for global ideologies. Saville's appropriation of European avant-garde imagery was, in his words, about "changing the here and now instead of going somewhere else." That was something I could relate to, a way of pushing the intensely local up against something too big to grasp. Cities shrink to the scale of neighborhoods, and boroughs are promoted

to global capitals. When I eventually began listening to the Bowie records in Mark's collection, I'd hear the line "I've lived all over the world, I've left every place" and it made an intuitive kind of sense. At that time it didn't much matter that my here and now was the names of Cotswold villages, that I'd barely been an hour down the motorway to London, let alone Tokyo or Berlin. Wheatley, Staten Island, Great Milton, Massif Central, Cuddesdon, São Paolo. Those were the conditions of life under pop.

Jon Savage laid out these principles in his liner notes to the band Saint Etienne's debut long player, *Foxbase Alpha*, released in 1991:

Down in Camden, London is in your throat. The lowest point in the city, a sink for pollution, noise, destitution. But its here that you find the raw material to make the world the way you hear it. Walking through the congested streets and alleys, you're assaulted by a myriad of sounds, looks and smells from all over the world, each with its own memory and possibility. How to make sense of this? Go with the flow, find what has been forgotten, put it together in a new way. Today's hauls are: "Mash Down" by Roots and "Bamba in Dub" by Revolutionaries, a battered single telling you how to convert LSD into decimal currency, a couple of Northern Soul compilations on Kent, overpriced UK psych singles on labels like Camp and Page One. The look is easy, wigs, turtlenecks and corduroys: the rhythms of the moment are playing non-stop in Zoom.

The idea is mental freedom: the transformation of the familiar. Primrose Hill, Staten Island, Gospel Oak, Sao Paolo, Boston Manor, Costa Rica, Arnos Grove, San Clemente, Maida Vale, Studamer: Stay busy, out of phase, in love.

I first read Savage's manifesto on the back of a copy of *Foxbase Alpha* in the HMV record shop on Cornmarket Street, Oxford. What was Northern Soul? What and where was Zoom? Where, for that matter, was Camden? I had to know.

But at the time I was attending my local comprehensive, miserably divided along tribal lines into Casuals and Goths. Karl and Mark had been to the same school I was at a decade before, and left with a handful of basic grades and bitter memories of bullying. The campus was, however, unusual for a state school. At one end were functional brick classrooms and halls constructed during the 1970s and '80s, a set of temporary Portakabins that either for lack of funding or excess of inertia had become permanent classrooms, and a pair of WWII-era hospital huts that the US army had built in the 1940s, repurposed for the art department. At the other end of the grounds was a seventeenth-century manor house with a wooded, moated island and large playing fields. Looking back, it was one of the strangest backdrops for a state education. The school served children from Wheatley, from council estates on the eastern outskirts of Oxford, surrounding farms, and well-to-do commuter-belt villages. I remember, in class aged thirteen, one pupil arrived covered in mud from his mother's farm and had no time to wash nor spare clothes to wear, while another was talking

about where his parents were taking him skiing that half-term. Look one way and you could be on the set of a BBC costume drama. Turn your head and you were in a gritty Ken Loach film. The school's class hierarchies were palpable but they felt fluid, interchangeable.

Between the ages of twelve and fourteen, I played in a band called The Jennifers. My classmate Gaz had asked me to join. We were precocious, playing cover versions of songs by The Smiths and The Cure, all learned by ear from our older brothers' record collections. Other, more illicit, influences floated in from the edges. In the late 1980s and into the early '90s, small illegal raves arrived in the countryside surrounding Wheatley: acid house parties spreading beyond the cities to disused airstrips and fallow fields. You could hear them at night, or cycle past them on a Saturday if it was a weekender that hadn't been shut down by the police. The raves were occasionally organized by groups of new age travelers who would camp on Shotover Hill, just beyond the village. They were a common sight at that time. On trips to Wales or to Dorset during the school holidays with Mum and Dad, we'd often pass the "peace convoys" on the road, their mud-splattered vans and brightly painted buses being shunted by police from one part of the country to the other. The travelers were the folk devils of the press at that time, their sound systems, with thrillingly shadowy names such as Spiral Tribe, Bedlam, and Mutoid Waste Company, filled the TV and radio news. Teenagers from school would go and score weed from the travelers up on Shotover. It seems almost quaint now, but flyers were distributed across Wheatley warning parents to keep an eye out for perforated sheets of LSD circulating

among their children who might mistake them for stickers or stamps. The 1960s teleported into the present again. Time travel wasn't so unusual for a village steeped in history. Each year, a play about Wheatley was staged. It would be written by the local playwright, involve locals in all the roles, and each time tell a different story about the community and its past. If the acting was hammy or the sets wobbly, it hardly mattered; what mattered was the value the community attached to telling stories about itself; pretending as a way to find commonality.

I was aged fifteen or sixteen when I first started making day trips up to London on my own. Heavily into style magazines such as *i-D* and *The Face,* along with the British music weeklies, the capital was the most impossibly exciting place I could imagine; a potential life in art or music seemed embedded in every one of the city's grimy, yellow stock bricks. Figuring out the mechanics of urban subculture was detective work. I could look at *The Face* and see what T-shirts the kids wore, how they did their hair, but the photograph might not show what shoes or trousers were in fashion: that's where guesswork came in. Local vernacular styles developed by pretending you knew the whole picture. There was no internet to refer to: those conditions were not necessarily better nor did they carry any more authenticity than today; they were just different. Grunge never caught my interest, and Kurt Cobain's suicide in 1994 did not hold as much significance for me as it did for others my age. Instead I lost myself in jungle and techno tapes, in music by bands such as Suede, Blur, Ride, Pulp, The Auteurs, Elastica, and other groups then strongly associated with either Oxford or London. It became

a task of utmost importance to work out what Northern Soul was. Hours were spent devouring Mark's record collection at home: Bowie, Japan, B-52s, Kraftwerk, The Cramps, Orchestral Maneouvres in the Dark, Kate Bush, The Smiths, Communards, Thomas Dolby. At my Saturday job in an Oxford bookshop, I would swap compilation tapes of music with Steve, an older colleague who opened my ears to Eno, Can, Throbbing Gristle, Steve Reich, and The Fall. I had another job working as a waiter in a cafe; one colleague was a performer from the Rambert Dance Company convalescing from a back injury, who got me listening to dub music as we opened up each morning. I was lucky enough to grow up during a period of progressive television programming: BBC and Channel 4 would run seasons devoted to New Hollywood cinema, or the French New Wave. It was late night television where I first saw films by Kenneth Anger and Sally Potter, not in museums or at art-house cinemas. One night while sick at home with the flu in my early teens, I insisted on listening to BBC Radio 3, because I thought the classical music broadcast on that station would be soothing. Instead I heard the dissonant, experimental sounds of John Cage; I was too ill to get out of bed and turn the radio dial, too captivated and yet unnerved by the alien harmonies of his "prepared pianos" to want to tune out. All of this was my raw material for making the world the way I saw and heard it.

By the time I hit seventeen, my friend Gaz, along with The Jennifers' drummer Danny, had left school to take his chances playing in the band Supergrass. Seeing them perform on the TV show *The Word* one Friday night only made me further aware that Wheatley was not the place for me.

But a village could be the place for other schemes. In the summer of 1994, a school friend built a small radio transmitter using mail-order parts. That July and August, along with a couple of others who were heavily into DJ-ing, we ran a pirate radio station called Bush FM broadcasting nonstop rave, jungle, and house. The station had a range of one mile, our listeners just the odd friend tuning in on a car radio, but audience reach was not the point. The fun of it, the possibility of even doing it in the first place—that was the point.

Soundtracking as much of my day as I could, music became an agglutinator. Experience and memory clung to it like insects on flypaper. To this day I find it hard to dissociate Bowie from the fogged-up windows in the kitchen at home as Mum cooked dinner, or separate Ride's music from the way the sun hit my room when I had to get up for school. In turn, atmospheres of place added drama to the music I was collecting. Sat on the Oxford Tube coach as it drove through suburban London along the Westway, the view out of the window snagged on the music that played on my Walkman. Park Royal, Massive Attack, Acton, Pet Shop Boys, White City, Aphex Twin. Place names, Tarmac, and brick glommed onto music like barnacles on a ship.

Mum and Dad used to insist I get the earliest coach into the city so I could be back home in time for dinner. This meant that some of my earliest memories of being in London as a teenager involved mooching around empty, early morning streets waiting for shops or art museums to open. I learned its atmospherics—the smell of the Tube, growling black cabs— and enjoyed recognizing street names from songs and movies, constructing mental narratives and wiring pop-historical

connections of my own. Art, music, clothes, magazines, films: these were my time machines, my teleport devices, and armed with these I knew that one day, London would belong to me. My strategy was mental freedom: the transformation of the familiar. I would eventually live in London for ten years, discovering that most of the interesting people I met there had grown up outside the city, drawn to it by similar promises of a life less ordinary learned through the art, music, and fashion that London disseminated.

"Primrose Hill, Staten Island, Chalk Farm, Massif Central . . ." Wheatley, Oxford, London, New York. Dreaming big in small towns, sweeping sentiment and an eye for detail, it all sounds pleasingly, simplistically, romantic. But doesn't all that daydreaming imply a snobbery of geography that equates the small town with the small mind and the big city with promises of success and creative self-realization? Even if you get down the motorway from Wheatley to London there's always that moment when you have to acknowledge that you're not somewhere even more exciting—Mexico City, say, or Los Angeles—you're stuck in a bedsit in Rotherhithe. Unless displaced somewhere by war, money, or famine, we like to think of ourselves as having an authentic right to a place. It is other people who are "immigrants," not us, not our forebears. It's those people down the street who are gentrifying the neighborhood: we, after all, are sensitive to cultural context and would never dream of eroding what attracted us here in the first place, would we? Surely we're not pretentious gentrifiers, we just came here because we dreamt of leaving our small town for a life of the mind in the big city, right?

My brother Karl eventually settled overseas. Traveling light became too heavy, a life on land offered new possibilities. Mark stayed in the north and founded his own interior design firm in 1994. His teenage *World of Interiors* subscription now looks like an act of predestination. I was strongly encouraged by two art teachers—Bridget Downing and Bob Read—to apply to art school. They pushed me toward the Ruskin School of Fine Art, Oxford University's small studio fine art department. A classist usage of the word "pretentious" might describe a teenage pupil of a state comprehensive school wanting to go and study fine art at Oxford University but it was a pretentious ambition that changed my life forever. There I came into contact with new ideas, people with perspectives new to me. Three years later I moved to London, got a job on an art magazine, started a career as an editor and writer, and ten years after that I found myself living in New York.

At Oxford, another student once put me down by saying, "It must be nice doing your hobby as a degree." The idea that fine art could be a serious course of study wound him up, presumably because he could not understand how the *amore* of the amateur could translate into a serious life pursuit. And yet in some sense he would prove to be right: I have no qualification for what I do. I never studied art history or journalism, and I learned to write and to edit on the job. I became a professional art critic by doing it, by feeling my way through. In that sense my career as a "professional" magazine editor and art critic has been along the same amateurist spectrum as any number of other pursuits I've followed, making music or art.

With friends from art school I started a record label called Junior Aspirin Records. Together we have made music in bands with absurd names such as Advanced Sportswear, Big Legs, The God in Hackney, Mysterius Horse, Norwegian Lady, and Skill 7 Stamina 12. Music has never made us a penny but it's taken us across the world, from Eastern Europe to the West Coast of the US. In 2012 we found ourselves performing in front of an audience of three thousand people in Heihe, a small city on the Chinese side of the Amur River, across from Siberia. (It was my second visit to China; my first had been at the end of a six-week journey by container ship from Thamesport, England, to Yangshan Port, near Shanghai. The weeks of isolation at sea, with the small German and Filipino crew for company, gave me a pragmatic perspective on my life in the art world.) We played our "pretentious" experimental music for three hours and at the end, found ourselves signing autographs for the crowd of local teenagers who had invaded the stage. Our music is not popular in any conventional sense, but we are amateurs free of professional constraints and rules governing how we write and play together.

I would never have followed these paths without Mum and Dad's example and encouragement. Mum comes from a working-class farming family in the mountains of North Wales. She left the farm to study for clerical qualifications and moved around, from Wales to Canada and back again, eventually ending up in Oxford. She had Karl and Mark at a young age and raised them as a single mother for much of their early lives. Mum's fortitude is legendary in our family. I think of this every time I pass through New York's Grand Central Station. Returning to Britain from Canada in the

late 1960s, she crossed the continent alone with the boys by train. Arriving in New York a day before their ship was due to depart for Southampton, she and my brothers spent the night at Grand Central, unable to afford a place to stay. It was in Oxford that she met Dad. He was brought up in an Irish Catholic family in Rochdale: his mother a nurse, his father a soldier and peacetime primary school headmaster. Packed off to a spartan religious boarding school in Manchester at a young age, he was eventually sent to the Venerable English College seminary in Rome to train as a priest. There he experienced the tumults of the 1960s through the lens of the Vatican. His understanding of Marxism in communist Italy came from a German Jesuit academic teacher who had been taken at Stalingrad and studied dialetical materialism in a Soviet POW camp. Dad raised one hundred volunteers to dig out a hospital for the poor in Florence during the 1966 flood, built a road and the foundations of a primary school in rural Greece just as the 1967 colonels' coup unfolded, and saw the reform revolution of Vatican II first hand. Countless stories from this time filled my childhood: getting into a private papal audience on the pretense of translating; performing Beethoven's *Ode to Joy* on bottles filled with water, combs and tissues, car horns, tins, and toilet brushes in the Jesuit university matriculation ceremony. He saw Dorothy Tutin and the Royal Shakespeare Company perform excerpts from Shakespeare in front of the pope and his cardinals, including Wolsey's remorse scene from *Henry VIII*—the scarlet of the actors facing down the scarlet of the audience. Once he accidentally knocked through a cellar wall into someone's basement kitchen in an archaeological hunt below Rome.

He and colleagues were ejected from a pilgrim mountain shrine for questioning the "miracle" by which a portrait of the Virgin hung unattached from the wall.

After ordination, he returned to Britain where he worked on a Manchester inner city estate. The church had other plans for him, and eventually dispatched him to Oxford University, where he gained a degree in history and a crisis of faith in Catholicism. He left the clergy around the same time he met Mum and they married after a whirlwind romance, settling in Wheatley. They had little money, and so Dad retrained as a teacher, supplementing the family income with weekends in the Territorial Army. Until his retirement in 2005, he taught vocational studies to disadvantaged teenagers at a comprehensive school in north Oxford, using the summer holidays to write books on topics ranging from Roman numismatics to the English Civil War. He would leap at any excuse for adventure, big or small, often taking me and Mum along for the ride: organizing local archaeological digs on Saxon burial sites, trying to convert a toy cannon into a working experiment in ballistics for his classes at school, salvaging old signs and signals from the disused Wheatley railway station, traveling to the mountains of Northern California to research Irish emigration and the Gold Rush.

Money could be tight but our family was rich in other respects. Mum had been working in Liverpool when American rock'n'roll, Italian-style coffee bars, and cinemas showing foreign films arrived. She understood what culture could do if you could find a way in. It was Mum who took me to London to visit the Tate Gallery, where I first went to a Turner Prize exhibition of contemporary art and first saw work by Richard

Hamilton, David Hockney, Roy Lichtenstein. She took me to the theater in Oxford, where we watched Shakespeare, and once caught a production of Bruno Schulz's *Street of Crocodiles* by Simon McBurney's Complicite company. Eastern European surrealism was its look—all wooden furniture and brown 1930s suits, a little Kafka-by-numbers perhaps. It was striking in ways that might appear pat to me today, but at the time I had never seen anything like it. Neither of us knew, beforehand, who Complicite or Schulz was; we went because the poster outside the theater looked good, the tickets were cheap, and the blurb on the flyer made it sound different. Leaving the Oxford Playhouse that evening, we felt exhilarated and entertained. It was an experience we still talk about today.

Mum bought me novels and books on art with her staff discount at the Oxford University Press, where she worked as a production manager. It was Mum who would gamely take my pocket money into the city and buy whatever record I was desperate to get that week. Dad took us everywhere in our imaginations: he brought places alive with his love of archaeology and local history. We rarely went on foreign holidays, but trips to Dorset or Wales would be packed with trips to hidden beaches, standing stones, or castles—experiences that fostered in me a strong emotional connection to the British landscape. Both Mum and Dad had seen the world, they knew that out there was where you had to be, however you got there. All you first had to do was transform the familiar. Without the possibility of transformation, Mum would never have left the farm in Wales, and Dad would still be a priest following what the church would call his "true" vocation—

authentic only to institutional rules. My siblings would never have felt enabled to try something different in their lives.

My oddball middle-class upbringing left me understanding pretension as a positive. I associated it with the safe space of the arts, with the adventures of the brothers I loved, with the houses that kind people across the road lived in. With the history books Dad wrote during school holidays and the plays Mum would take me to see and all that they had been through in their lives, which later provided me with encouragement and freedom. I was lucky. I understood pretension as permission for the imagination.

"Mysterious names holding the key to your heart" is how the narrator of Paul Kelly's day-in-the-life documentary of London, *Finisterre,* describes the stations on the Tube map. Burnt Oak, Chalk Farm, Angel, Blackfriars. I've lived in New York since 2009. My list of stations these days might include Bowery, Canal Street, Atlantic Avenue, Grand Central 42nd Street, and these have a romance of their own. My atmospherics have changed, the polarities have reversed. Britain has taken on a more generalized form, and New York is now mapped in detail: Greenpoint, Manchester, Sunset Park, Birmingham, Harlem, Brighton, SoHo, Glasgow, Long Island City, Colwyn Bay, Lower East Side, Wheatley. A few blocks from my apartment, there's an Essex Street, a Ludlow Street, a Norfolk Street, and a Suffolk Street. I wonder what these British place names would have conjured for me had I grown up on the Lower East Side rather than in the English countryside? "Go with the flow, find what has been forgotten, put it together in a new way." Stay busy, out of phase, in love.

SOURCES

Books and Essays

Viv Albertine, *Clothes, Clothes, Clothes, Music, Music, Music, Boys, Boys, Boys* (2014)

Jeffrey C. Alexander, *Performance and Power* (2011)

Aristotle, *Rhetoric* (4 BC)

Peter Bailey, *Popular Culture and Performance in the Victorian City* (1998)

Hugh Barker and Yuval Taylor, *Faking It: The Quest for Authenticity in Popular Music* (2007)

Howard S. Becker, *Art Worlds* (1982)

Howard S. Becker, *Outsiders: Studies in the Sociology of Deviance* (1963)

Jean Benedetti, *The Art of the Actor* (2005)

Marshall Berman, *The Politics of Authenticity: Radical Individualism and the Emergence of Modern Society* (1970)

Thomas Bernhard, *Woodcutters* (1984, English translation 1987)

Klaus Biesenbach, "Introduction," *Björk* (exhibition catalog, 2015)

Pierre Bourdieu, *Distinction: A Social Critique of the Judgement of Taste* (1979, English translation 1984)

Michael Bracewell, *England Is Mine: Pop Life in Albion from Wilde to Goldie* (1997)

Michael Bracewell, *The Nineties: When Surface Was Depth* (2003)

Peter Brook, *The Empty Space* (1968)

Ronald Brownstein, "Fantasy and Reality Intersect on 'K Street,'" *Los Angeles Times* (September 16, 2003)

Judith Butler, *Gender Trouble* (1990)

John Carey, *The Intellectuals and the Masses: Pride and Prejudice among the Literary Intelligentsia 1880–1939* (1992)

Quentin Crisp, *The Naked Civil Servant* (1968)

Cameron Crowe, David Bowie interview, *Playboy* (September 1976)

Ben Davis, *9.5 Theses on Art and Class* (2013)

Declan Donnellan, *The Actor and the Target* (2002)

Brian Eno, *A Year with Swollen Appendices* (1996)

Joseph Epstein, *Snobbery: The American Version* (2002)

Richard Fariña, *Been Down So Long It Looks Like Up to Me* (1966)

Dan Fox, "Act Natural: David Levine Talks to Dan Fox about Performing and Identity," *frieze* 156 (June–July–August 2013)

Dan Fox, "Altercritics," blog.frieze.com (2009)

Dan Fox, "Aspiring to the Condition of Cheap Music: Interview with Mark Leckey," *Mark Leckey: On Pleasure Bent* (eds. Patrizia Dander and Elena Filipovic, 2014)

Dan Fox, "Prize Fights," blog.frieze.com (2008)

Thomas Frank, *The Concept of Cool: Business Culture, Counterculture, and the Rise of Hip Consumerism* (1997)

Harry G. Frankfurt, *On Bullshit* (2005)

Simon Frith and Howard Horne, *Art into Pop* (1987)

Paul Fussell, *Class: A Guide through the American Status System* (1983)

Mary Gaitskill, "The Easiest Thing to Forget," in *Let's Talk about Love: Why Other People Have Such Bad Taste* by Carl Wilson and contributors (revised and expanded edition, 2014)

J. R. Glaves-Smith and George Melly, *A Child of Six Could Do It! Cartoons about Modern Art* (1973)

Erving Goffman, *The Presentation of Self in Everyday Life* (1959)

Adam Gopnik, "The Outside Game," *The New Yorker* (January 12, 2015)

Harvard Business Review 93, no. 1/2 (January–February 2015)

Lucas Hildebrand, *Paris Is Burning: A Queer Film Classic* (2013)

Will Hodgkinson, "So, What Did You Learn at School Today?" *The Guardian* (April 19, 2009)

Will Holder, "Will Holder Speaks the Poetics of CONCRETE POETRY and Documenting the Work of FALKE PISANO," *Dot Dot Dot* 17 (Winter 2008–9)

K-Hole, "Youth Mode: A Report on Freedom," khole.net (2014)

Jerzy Kosiński, *Being There* (1971)

Daniel J. Levitin, *This Is Your Brain on Music: The Science of a Human Obsession* (2006)

Lucy Lippard, "The Pink Glass Swan," *The Pink Glass Swan: Selected Essays on Feminist Art* (1995)

Joseph Litvak, *Strange Gourmets: Sophistication, Theory, and the Novel* (1997)

David Mamet, *True and False: Heresy and Common Sense for the Actor* (1997)

Andrew Marr, "It's Rude, Witty, but Is It Art?" *The Observer* (November 26, 2000)

Richard Maxwell, *Theater for Beginners* (2015)

Momus, "Kriedler/Momus Mnemorex Tour Journal: Chapter 2: Rumination on the Autobahn," imomus.com (2000)

Paul Morley, "There Was Once a Time When the Only Art I Had on My Walls Was by Peter Saville," in *Designed By Peter Saville* (2003)

George Orwell, "Politics and the English Language" (essay, 1946)

Jonathan Raban, *Soft City* (1974)

Rory Rowan, "SO NOW!: On Normcore," *e-flux* 58 (October 2014)

Tyler Rowland, *Artist's Uniform #13: Once Upon a Time . . . The End (5/16/2015)* (exhibition handout, 2015)

J. D. Salinger, *The Catcher in the Rye* (1951)

Jon Savage, Saint Etienne, *Foxbase Alpha* (liner notes, 1991)

Richard Sennett, *The Culture of the New Capitalism* (2006)

David Sheppard, *On Some Faraway Beach: The Life and Times of Brian Eno* (2008)

Edith Sitwell, *English Eccentrics: A Gallery of Weird and Wonderful Men and Women* (1933)

Beverly Skeggs, *Class, Self, Culture* (2004)

Susan Sontag, *Against Interpretation and Other Essays* (1966)

Constantin Stanislavski, *An Actor Prepares* (1926, English translation 1937)

Charles Taylor, *The Ethics of Authenticity* (1991)

William Makepeace Thackeray, *The Book of Snobs: By One of Them* (1848)

Lynne Tillman, *What Would Lynne Tillman Do?* (2014)

Scott Timberg, *Culture Crash: The Killing of the Creative Class* (2015)

Lionel Trilling, *Sincerity and Authenticity* (1972)

Various contributors, *David Bowie Is* (exhibition catalog, 2013)

Various contributors, *Peter Saville Estate 1–127* (2007)

Andy Warhol, *The Philosophy of Andy Warhol (From A to B and Back Again)* (1975)

Oscar Wilde, "The Soul of a Man under Socialism" (essay, 1891)

Raymond Williams, *Keywords* (1976)

Carl Wilson and contributors, *Let's Talk about Love: Why Other People Have Such Bad Taste* (2014)

D. W. Winnicott, *Playing and Reality* (1971)

Virginia Woolf, *Orlando: A Biography* (1928)

Peter York, *Style Wars* (1980)

Sharon Zukin, *Naked City: The Death and Life of Authentic Urban Places* (2010)

Film and Television

Carlton (Simon Martin, 2003)

Cracked Actor (Alan Yentob, 1974)

The Century of the Self (Adam Curtis, 2002)

"The Critics," *A Bit of Fry and Laurie* (TV series, 1989)

David Bowie—Five Years: The Making of an Icon (Francis Whately, 2013)

It Couldn't Happen Here (Jack Bond, 1988)

JerUSAlem (Richard Belfield, 1987)

K Street (TV series, 2003)

The Last Days of Disco (Whit Stillman, 1998)

The Mighty Boosh (2004–7)

Paris Is Burning (Jennie Livingston, 1990)

Performance (Donald Cammell and Nicolas Roeg, 1970)

"The Psychiatrist," *Fawlty Towers* (TV series, 1979)

The Servant (Joseph Losey, 1963)

Tanner '88 (Robert Altman, 1988)

This Is Spinal Tap (Rob Reiner, 1984)

Trading Places (John Landis, 1983)

The Trip (Michael Winterbottom, 2010)

Withnail and I (Bruce Robinson, 1987)

"Working Class Playwright," *Monty Python's Flying Circus* (TV series, 1969)

Music

Laurie Anderson, "O Superman (For Massenet)" (1982)

Afrika Bambaataa, "Planet Rock" (1982)

Bauhaus, *The Sky's Gone Out* (1982)

The Beatles, *Sgt. Pepper's Lonely Heart's Club Band* (1967)

Kate Bush, *The Kick Inside* (1978)

The Clash, "Spanish Bombs" (1979)

Brian Eno, *Taking Tiger Mountain (By Strategy)* (1974)

The Fall, *I Am Kurious Oranj* (1988)

Fripp and Eno, *No Pussyfooting* (1973)

Marvin Gaye, *What's Goin' On* (1971)

Genesis, *The Lamb Lies Down on Broadway* (1974)

Jay Z, "Picasso Baby" (2013)

Joy Division, *Closer* (1980)

Kraftwerk, *Trans Europe Express* (1977)

Led Zeppelin, *Led Zeppelin IV* (1971)

Madonna, "Vogue" (1990)

Magazine, *Real Life* (1978)

The Manic Street Preachers, "A Design for Life" (1996)

The Modern Lovers, "Pablo Picasso" (1976)

Parliament-Funkadelic, *Mothership Connection* (1975)

Pet Shop Boys, "Left to My Own Devices" (1988)

Pink Floyd, *The Dark Side of the Moon* (1973)

Pulp, "Common People" (1995)

Jonathan Richman, "Door to Bohemia" (2011)

Roxy Music, *Roxy Music* (1972)

Saint Etienne, *Foxbase Alpha* (1991)

Scritti Politti, "Jacques Derrida" (1982)

Talking Heads, *Fear of Music* (1979)

"Blue" Gene Tyranny, "Leading a Double Life" (1978)

The Velvet Underground, *The Velvet Underground & Nico* (1967)

ILLUSTRATIONS

PAGE VIII. David Noonan, *Untitled,* 2007. Silkscreen on linen collage, 114 × 154 cm. Courtesy of Stuart Shave / Modern Art, London.

PAGE VIII. David Noonan, *Untitled,* 2015. Silkscreen on linen collage, 78 × 58 cm. Courtesy of Roslyn Oxley9 Gallery, Sydney.

PAGE X. David Noonan, *Untitled,* 2015. Silkscreen on linen collage, 78 × 58 cm. Courtesy of Roslyn Oxley9 Gallery, Sydney.

PAGE X. David Noonan, *Untitled,* 2010. Silkscreen on linen collage, 114 × 154 cm. Courtesy of David Kordansky Gallery, Los Angeles.

PAGE 8. Steven Claydon, *The Author of Mishap,* 2005. Copper powder in resin, peacock feather, wood, hessian, urine, 36 × 22 × 24 cm. Courtesy of the artist and Sadie Coles HQ, London.

PAGE 25. Frances Stark, *Clever Moment in Clever/Stupid Revolution Repurposed,* 2015. Sumi ink on arches paper with inlay, 158 × 115 cm. Photograph by Marcus Leith, courtesy of greengrassi, London.

PAGE 26. Frances Stark, *Stupid Moment in Clever/Stupid Revolution Repurposed,* 2015. Sumi ink on arches paper with inlay, 158 × 115 cm. Photograph by Marcus Leith, courtesy of greengrassi, London.

PAGE 40. Tala Madani, *Shadow* (from the series "Jinn"), 2011. Ink on paper, 89 × 59 cm. Courtesy of Pilar Corrias Gallery, London.

PAGE 56. Pablo Bronstein, *Terraces by Nash with an Attic by Soane,* 2011. Ink and watercolor on paper in artist's frame, 120 × 148 cm. Courtesy of Herald St., London.

PAGE 72. Mark Leckey, *BigBoxStatueAction,* 2003. Performance at the Duveen Galleries, Tate Britain, February 1, 2003. Courtesy of the artist and Cabinet, London.

PAGE 86. Glen Baxter, *There, as usual, was Edelson, delivering his post-structuralist analysis of the modern novel to the privileged few,* 1997. Courtesy of the artist.

PAGE 106. Marc Camille Chaimowicz, *Man Looking Out of the Window (for SM),* c. 1977. Photograph. Courtesy of the artist and Cabinet, London.

PAGE 118. The author on an archaeological dig, Wheatley, Oxfordshire, 1986. Family photograph. Courtesy of the author.

ACKNOWLEDGMENTS

A million thanks to Caroline Casey, Chris Fischbach, Amelia Foster, and Carla Valadez at Coffee House Press for publishing this book in the US and for their advice, enthusiasm, and patience. This book would not be the same without the generosity of the artists who kindly gave permission to reproduce their work: Glen Baxter, Pablo Bronstein, Marc Camille Chaimowicz, Steven Claydon, Mark Leckey, Tala Madani, David Noonan, and Frances Stark.

Pretentiousness: Why It Matters had its genesis in two essays and one talk: "Class Act," published in *frieze* magazine in 2009; "Train, Heave on to Euston!" which appeared in *Nothing's Too Good for the Common People: The Films of Paul Kelly,* edited by Sukhdev Sandhu and published by Texte und Töne in 2013 (greatly expanded here as the postscript); and "What Is Pretentiousness and Does It Make Me Look Good?" given in 2013 at the "Moonlighter Presents . . ." lecture series in New York City, organized by Stephanie

DeGooyer and Justin Martin. Trace elements from all three have found their way into this volume and I'd like to express immense appreciation to my colleagues at *frieze*, and to Sukhdev, Stephanie, and Justin for giving me not just those first opportunities to rehearse my ideas but also for the invaluable conversations that followed.

This book would not have been possible without the generous advice, recommendations, and collective intellects of Chloe Aridjis, Stuart Bailey, Mark Beasley, David Birkin, Michael Bracewell, Tim Braden, Brian Catling, Jonty Claypole, Paul Clinton, Andy Cooke, Peter M. Coviello, Mark Fisher, Ben Furstenberg, Tom Gidley, Richard Hartshorn, Jörg Heiser, The Hermeneutic Circle, Jennifer Higgie, Sarah Hromack, Andrew Hultkrans, Jennifer Kabat, Katie Kitamura, Adam Kleinman, Hari Kunzru, Annie Godfrey Larmon, Claire Lehmann, The Leopards & Horses, David Levine, Jenny Lord, Laura Lord, Jessica Loudis, Brenda Lozano, Simon Martin, Jodhi May, Tom McCarthy, Molly McIver, Nathaniel Mellors, Olivia Mole, Tom Newth, David Noonan, George Pendle, Mick Peter, Max Porter, David Reinfurt, Simon Reynolds, Tyler Rowland, Anna Saltmarsh, Bob Stanley, Polly Staple, Emily Stokes, Sam Thorne, Lynne Tillman, Johnny Vivash, Sam Walls, Marcus Werner Hed, Chris Wiley, and Constance Wyndham. Special mention must go to Sierra Pettengill for her encouragement, feedback, and kindness during the writing process.

Finally, my biggest love and thanks go to Glenys, John, Mark, Karl, Ellen, and Osian, my family, without whom none of this ever would have happened.

LITERATURE
is not the same thing as
PUBLISHING

FUNDER ACKNOWLEDGMENTS

Coffee House Press is an internationally renowned independent book publisher and arts nonprofit based in Minneapolis, MN; through its literary publications and *Books in Action* program, Coffee House acts as a catalyst and connector—between authors and readers, ideas and resources, creativity and community, inspiration and action.

Coffee House Press books are made possible through the generous support of grants and donations from corporate giving programs, state and federal support, family foundations, and the many individuals that believe in the transformational power of literature. This activity is made possible by the voters of Minnesota through a Minnesota State Arts Board Operating Support grant, thanks to the legislative appropriation from the arts and cultural heritage fund and a grant from the Wells Fargo Foundation Minnesota. Coffee House also receives major operating support from the Amazon Literary Partnership, the Bush Foundation, the Jerome Foundation, the McKnight Foundation, Target, and the National Endowment for the Arts (NEA). To find out more about how NEA grants impact individuals and communities, visit www.arts.gov.

Coffee House Press receives additional support from many anonymous donors; the Alexander Family Foundation; The W. & R. Bernheimer Family Foundation; the Archer Bondarenko Munificence Fund; the Elmer L. & Eleanor J. Andersen Foundation; the David & Mary Anderson Family Foundation; the Buuck Family Foundation; the Carolyn Foundation; the Dorsey & Whitney Foundation; Dorsey & Whitney LLP; the Knight Foundation; the Matching Grant Program of the Minneapolis Foundation; the Rehael Fund of the Minneapolis Foundation; the Schwab Charitable Fund; Schwegman, Lundberg & Woessner, P.A.; the Scott Family Foundation; the US Bank Foundation; VSA Minnesota for the Metropolitan Regional Arts Council; the Archie D. & Bertha H. Walker Foundation; and the Woessner Freeman Family Foundation.

THE PUBLISHER'S CIRCLE OF COFFEE HOUSE PRESS

Publisher's Circle members make significant contributions to Coffee House Press's annual giving campaign. Understanding that a strong financial base is necessary for the press to meet the challenges and opportunities that arise each year, this group plays a crucial part in the success of Coffee House's mission.

Recent Publisher's Circle members include many anonymous donors, Mr. & Mrs. Rand L. Alexander, Suzanne Allen, Patricia A. Beithon, Bill Berkson & Connie Lewallen, the E. Thomas Binger & Rebecca Rand Fund of the Minneapolis Foundation, Robert & Gail Buuck, Claire Casey, Louise Copeland, Jane Dalrymple-Hollo, Mary Ebert & Paul Stembler, Chris Fischbach & Katie Dublinski, Kaywin Feldman & Jim Lutz, Katharine Freeman, Sally French, Jocelyn Hale & Glenn Miller, Roger Hale & Nor Hall, Randy Hartten & Ron Lotz, Jeffrey Hom, Carl & Heidi Horsch, Kenneth Kahn & Susan Dicker, Stephen & Isabel Keating, Kenneth Koch Literary Estate, Jennifer Komar & Enrique Olivarez, Allan & Cinda Kornblum, Leslie Larson Maheras, Jim & Susan Lenfestey, Sarah Lutman & Rob Rudolph, Carol & Aaron Mack Charitable Fund of the Minneapolis Foundation, George & Olga Mack, Joshua Mack, Gillian McCain, Mary & Malcolm McDermid, Sjur Midness & Briar Andresen, Peter Nelson & Jennifer Swenson, Marc Porter & James Hennessy, Jeffrey Scherer, Jeffrey Sugerman & Sarah Schultz, Nan G. & Stephen C. Swid, Patricia Tilton, Stu Wilson & Melissa Barker, Warren D. Woessner & Iris C. Freeman, Margaret Wurtele, and Joanne Von Blon.

For more information about the Publisher's Circle and other ways to support Coffee House Press books, authors, and activities, please visit www.coffeehousepress.org/support or contact us at info@coffeehousepress.org.

Coffee House Press began as a small letterpress operation in 1972 and has grown into an internationally renowned non-profit publisher of literary fiction, essay, poetry, and other work that doesn't fit neatly into genre categories.

Coffee House is both a publisher and an arts organization. Through our *Books in Action* program and publications, we've become interdisciplinary collaborators and incubators for new work and audience experiences. Our vision for the future is one where a publisher is a catalyst and connector.

DAN FOX is a British writer, musician, editor, and filmmaker currently living in New York. He is the co-editor of *frieze,* Europe's foremost magazine of contemporary art and culture.

Pretentiousness: Why It Matters was designed by
Bookmobile Design & Digital Production Services.
Text is set in Warnock Pro.

Printed in the USA
CPSIA information can be obtained
at www.ICGtesting.com
JSHW082341140824
68134JS00020B/1818

9 781566 894289